GOD'S HAND WAS IN IT ALL

GOD'S HAND WAS IN IT ALL

THROUGH THE LORD WE CAN ALL PULL THROUGH

TRACIE SEATTLE WATERS

In the beginning God created Heaven and Earth, Genesis Chapter 1-1, and the word of the Lord came unto me saying before I formed thee in the belly I knew thee, and before thou came forth out of the womb I sanctified thee, and I ordained thee, Jeremiah Chapter 1-verse 4-5.

iUniverse, Inc.
New York Bloomington

God's Hand Was In It All
Through the Lord We Can All Pull Through

iUniverse books may be ordered through booksellers or by contacting:

iUniverse
1663 Liberty Drive
Bloomington, IN 47403
www.iuniverse.com
1-800-Authors (1-800-288-4677)

Because of the dynamic nature of the Internet, any Web addresses or links contained in this book may have changed since publication and may no longer be valid. The views expressed in this work are solely those of the author and do not necessarily reflect the views of the publisher, and the publisher hereby disclaims any responsibility for them.

ISBN: 978-1-4502-5759-6 (sc)
ISBN: 978-1-4502-5760-2 (ebk)

Printed in the United States of America

iUniverse rev. date: 09/16/2010

CHAPTER 1:

MY EARLY YEARS

I was born in February 28, 1966 a daughter among seven siblings. I am the youngest of them, born and raised in Cleveland, Ohio. I can begin the story about my life with some history of my father and mother, Bill and Mary Watson, who were both born down in Alabama. They practically grew up together, living in the same neighborhood and going to the same school. They played together as kids and gradually became more than friends. They loved each other. In 1951 Bill asked Mary's father and received permission to marry her.

Times were tough back then, particularly for African Americans. This was even more so in the state of Alabama. Bill struggled to find work to support his new bride and a newborn baby son who had just come along. It wasn't long before Bill's great uncle in Cleveland was on the phone, talking about countless new opportunities for work up

north. So they hopped on a train, my father with a bag containing all of their clothes. My mother was carrying a young son with nothing else but the sandals on her feet. They headed to Ohio in the year 1952, saying goodbye to Alabama and closing that chapter of their young lives.

It was a typical late fall in Ohio. A touch of cold wind was sweeping off of Lake Erie and blowing hard across the city, a grey and busy industrial center filled with thick smoke from the factory plants. My mother often recounted her first ever feeling of the damp, cold air upon her feet. It was a strange sensation for a girl who was raised up in Alabama.

They first moved in with my great uncle Bill and like so many other Southerners, they tried to adapt to a life and a culture that was so new to them. My parents were still both very optimistic at this time. Except it turned out that it was harder than expected to find work. The economy in Cleveland started to slow down and show some troubling signs. Hard working men with years of experience were being laid off and a feeling of uncertainty fell all across the region.

Soon my mother was off to find a job in order to make ends meet. She quickly found work at a downtown clothing shop. Meanwhile the prospects for my father were growing dimmer by the hour. The responsibility for support was growing upon my mother's shoulders. She was forced into the role of breadwinner and this affected my father deeply.

My father was always having a hard time keeping steady work. Even when a small opportunity would come up, something would happen soon enough and that would be the end. He couldn't stick with it. For whatever reason he was just not getting his life together. But then his best opportunity came along, and just like that he had a second chance to make things right. My father was hired at the Chevrolet plant as a maintenance man. That offered good pay and good benefits for the family. Both of my parents hoped for a bright future when he got that job.

My parents then had another child in 1955, a baby girl. By then my mother was keeping up the dual role of earning money and being a full time parent. The children kept coming along until there were six all together.

The original intention with each child was for more love, more promise and more good fortune for the family. Then, gradually things began to unravel for my parents. There was a growing amount of strain regarding their finances. A year before I was born they had to make a decision that left them feeling a ton of regret. Because of a lack of money, they felt the need to send off two of their children to live with relatives back in Alabama.

Both of my parents took that decision hard. It was a wake up call to the state of their affairs. There was a load of wounded pride there. My father felt like a failure. Even with the good job at Chevrolet he no longer felt he was able to provide for the family, to buy clothes or put

enough food on the table. I feel this was a major turning point in their lives, because by all recollection, things just went downhill from there fast.

Any dreams Bill and Mary had for their lives had quickly unraveled to the point of hopelessness. My father kept on going to work, but by this time his confidence was deteriorated. The pressure he heaped on his conscience caused him to start drinking heavy, making a bad situation much worse. The man eventually had a nervous breakdown. It was just around that same time my mother found out she was pregnant with me.

My mother was sure of one thing in life, and that was that she did not want any more children. Neither did my father, which provided at least one issue that they could agree on. That's when I truly believe the spirit of rejection entered the womb. By having had six children before me to care for already, my mother was scared and embarrassed at the prospect of trying to support a seventh.

I am certain that we all have our close calls, and I feel like the devil always wants to get the best of us. We are fortunate for each day, and I think back on why things happen the way they do. But God has a purpose, and a plan for everyone. So whenever I ever felt unwanted my thoughts would return to these close calls. I reasoned that there must be a reason to live when you get past a bad situation that could have gone either way.

There was a day when my mother was driving home from work when she got in an accident. At the time she was eight months pregnant with me. Her stomach hit the steering wheel hard. Glory be to God everything was all right with me and my mother, and I was born two months after the accident. Although she decided to keep me, she never did give me a chance to feel welcome.

I was fortunate enough to be given a second chance at life. And I would get even more chances further on. My first memory was back when I was three years old. My family was out to eat at a downtown restaurant when I suddenly started to choke really bad. I started to feel a sense of panic that quickly lapsed into a numb feeling of darkness. My family thought they lost me at one point, but thankfully my father knew c.p.r. and he gave me a chance to start my breathing again. And I give thanks to God for He continues to save me. The Lord said I have come that you have life more abundantly, John Chapter 10-verse 10.

Even at five years old, I can clearly recall the corner at E. 102nd and St. Clair neighborhood where we used to live. It was a true community, a group of single family houses built close together with a fun, family type atmosphere. In those days all of the corner stores were still open, and the kids would run straight there after school to buy candy.

There were house parties and block parties in the summer, and the neighborhood was felt by all to be ideal and safe.

But the good nature of the community would not extend inside the four walls of my own house. In fact, the truth is that from as early on as I can remember, I was very scared.

When I was too young for school, my father watched over me before he had to go to work second shift. My mother worked normal hours and didn't come home until around 5:30 in the evening. My father would take me to a neighbor's house until my older brother and sister got out of school to take me home.

I have horrible memories of those times. Those were the darkest hours when something quickly gained control over most every aspect of my life. A portion of my misery was born of my very own brother and sister. After they would come pick me up from the neighbor's house, they would put me in a room they called the junky room. There was a blanket over the window blocking any light from outside. That's where they would tie me up, with my hands tight behind my back. They tied a gag around my mouth so nobody could hear me screaming out.

What was worse was that they put a blindfold on me, which caused me severe panic. I have always been terrified of the dark, and I would cry out for help, sometimes for hours until my mother come home from work. I remember it, always screaming though nobody could hear, afraid I would never escape the darkness, and not understanding why they had to do this to me. From the neighbor's attic

to that horrible room I went, each time hoping to God that it would just stop.

I have to let you know that this was not the fault of my parents. My mother and father never knew that was going on. Too afraid to mention this, I never once told. And that's the way it went with me being quiet.

I grew to understand that my brother and sister just resented having to watch me, and there resentment for me personally was a natural progression. I understood the heavy weight of intimidation. I learned to keep quiet and hold my head down. I thought that there had to be something wrong with me, that I must have deserved it. It wasn't until years later that I could get myself through this, past my own guilt, and I finally understood that it was not my fault, that they simply had no right to do that to me.

My earliest memories of my family give witness to a lot of suffering, not just with me, but mostly on account of the violence that was directed toward my mother. My parents would fight all the time, just about every day in fact. My father had a weakness for alcohol. Hard liquor mostly. When gin, his drink of choice wasn't available, he would make due with bottles and cans of beer instead. My father would be the kind of man to start drinking and not stop. Afterward he would be in the habit to hit my mother and accuse her of being with other men, and other similar wild accusations.

Her low demeanor was a fragile product of my father's abuse, and she was constantly in fear of him. She was afraid that for one moment things would seem fine, but at the turn of a hat his addiction could get the best of his better judgment. We all felt he could actually get angry enough to kill our mother.

Some times were uneventful, even bordering on normal. But that quiet time was always the calm before some up and coming storm. Me and my sisters and brothers would stay upset and afraid he would hit us also. But I can tell you the abuse was always centered on my poor mother.

Again, I was afraid at that point of my life. I was six years old and was confused and tormented of the abuse that was in my home. I could not think when I went to school; I just could not process my thoughts in a straight manner. I was in kindergarten and remember the day my father first took me to school. I was afraid for him to leave me at school because I felt very insecure being away from my father, even though this was the man who would beat my mother. It's strange thing to reconcile.

I'm about to tell something that may be hard for anyone else to believe or understand, but my father could be a loving man to us children. We eventually grew numb to the idea that he would possibly hurt us. But we did continue to worry for our mother, as my fathers drinking

and his unpredictable behavior made any sustained chance at a normal life impossible.

Naturally my mother wasn't able to take care of her children the right way in that environment. And considering it all, who could really blame her? She wasn't ever able to show the love and affection toward all of us. She could not give us the nurturing we needed because of her self esteem was low and her state of being was destroyed. She grew angry and bitter to us. She must have felt in her mind that someday it would change, and my father should love her in return. But he never did show any sort of love toward her through my observation.

There was times as a child when small, pockets of good memories did exist, except they were too fragile and too far between. Since both of my parents had roots in Alabama at the end of July we spent two weeks in the summer there for my fathers birthday. We all piled in and drove all the way down south in two cars.

I was in love with the idea of getting a closer relation to our relatives down there. It was hot, much hotter actually than what I was used to even with the humid summers in Cleveland. But I could feel the chance was there to connect with a loving family. At least I hoped as much.

As it went, the good feeling ended with the police coming to confront my father. He was once again out of his right

mind with his drinking, insane, and accusing my mother of various acts of adultery. Alabama was no refuge for what we all should have known what was going to happen with my father.

Now Christmas was the best time of the year for us. My parents made sure that everyone wore red outfits. And the idea of going out shopping put everyone in our family into a rare, good spirit. It seemed right that people should try to be happy at Christmas. Of course we didn't have much money at all, but there was some bit of honest effort to have a normal holiday.

The holiday would always begin with positive feeling, yet always end with my father ruining everything on account of his addiction. He would get so out of control that he would break our presents, and just tear all the decorations apart. I still get sad that my favorite gift, a desk that I had wanted so bad, ended up being broken into pieces.

He had stolen the joy out from under us. Ripped it away. When my father woke up, he was taken back at how sad I was. He promised that he was so sorry. He promised that he would never act out again. But my father didn't make a living on keeping promises.

The tension within our family was like a sickness that went on lingering for years, when suddenly my father

got sick with high blood pressure. We did not know how critical my father's health was at that time, and at the age of 43 my father suffered a heart attack and a stroke. He died on March 5, 1977. I was 11 years old and my brother next to me was 15. The rest of my siblings were grown up by then.

It was really hard on us because we did not know my father was very ill at that time, and we were not expecting him to die so soon. I thought he would live long enough to have the chances to change his lifestyle, to love my mother, to see me grown and have children. When my father died my mother really felt hurt and alone. She was afraid having two kids left to take care of, she did not really know what to do with us, or how to give us affection.

I had plainly gotten used to how things were when my father was around. He was so mean to my mother that I felt conflicted. And this is horrible to try and explain, but his abuse was directed at the woman who seemed to resent me and hate me so much.

Again, this is hard to reconcile but my father was different to me. Even when he was down, my father could find the energy to be so affectionate to me. He never insulted me, or tried to denigrate my like my mother would. Instead he would say that I was pretty, and he would play games with me when he was in a good presence of mind. I loved that

he would buy me Now and Later candy that we would share. And that to make me laugh he jokingly called them "Now and They's." This was the side of my father that I struggle to remember.

With my father gone, it gave my mother the opportunity to channel all of her pain and sadness right down at me. My older sister would remind me that the day I was born my mother wanted to die, saying she would rather drown herself in cold Lake Erie rather than go on living with me around. She also said that I was "born ugly" and repeat every chance she could that she didn't want any more kids. As far back as I can recall she was always there to tell me strait up that she didn't want me. In her eyes, my existence was for now and always just a bad mistake. I was never welcomed.

The falling out from my father being gone caused me to rethink about everything that was wrong with our family. It would have been much too simple to believe that once he was gone, that things could just change and start over like some kind of miracle. My father had a legacy that kept living on.

There was a time early on that my parents used to had friends in the neighborhood. But those days were gone. And I suddenly met with the strange awareness that for the last few years, my mother had rarely ever gone outside. My father was so jealous of her, so controlling,

that she became like some kind of a ghost figure. As my parents gradually withdrew from the social aspects of our wonderful little neighborhood, the neighbors lost track of my whether my mother was even alive at all.

Chapter 2:

I Felt I Was Different

I was 13 years old in 1979. Life was flying by us, and my sisters and brothers and I still could not pick up the pieces. Our family was shattered as it ever was. School was impossible for me, as I was never able to concentrate or calm down enough to do well in school. To put it mildly, I was uncomfortable there, and before long I simply withdrew and didn't talk to anyone. I had a plan and that plan was to hide deep into my own small world.

As bad as things were growing up, from very early on I had found a simple joy in doing work around our house. To me it always seemed like just a normal, positive thing to do. Whether it was making beds, sweeping or mopping no one ever had to tell me about it twice. Cleaning just became a sort of hobby for me. It offered me a chance to escape from my problems and feel like I was doing something good, finding a role for myself to help out in the family.

But outside of that I didn't have much going. And school was a different thing altogether. I couldn't keep focus and there was no visible progress or signs that I could improve. My mother responded to my problems by hitting me and calling me out, saying that I was just a dummy.

I knew I needed help. I had trouble seeing letters the right way, when I saw an "m" it looked to me like a "w." By then I became fearful of asking my mother for any help whatsoever. She would say "that's right, you heard what I said, you can't read letters because you're a dummy."

The school finally recommended that my only hope for education was to enroll in special classes for the learning impaired. Except when they tested me they soon realized that I didn't belong in special classes at all. The truth was, aside from my upside down letters, for the last seven years I was still living with a terrible secret. The dark hours had changed me forever.

It started when I was six years old, back in the neighbor's attic. It was an older boy, and that's all I'll say about his identity. But this boy, who was old enough to know right and wrong, coaxed me to become intimate with him. Afterward he saw that I was scared and feeling hurt. He gave me five cents, and said to keep everything quiet. He also made it clear that if I told anyone what we did, surely the both of us would be in a serious amount of trouble. He did things to me repeatedly

until one of my relatives found out what that boy was doing, and after seven years of sexual abuse, it finally stopped.

Again, I never did have the courage to tell my mother and father. For years I would just try to forget about what was happening and sometimes the forgetting worked. But it was at school where I struggled to overcome the feeling that I was dirty and not worthy at all. I stopped talking because I was so angry and ashamed at myself. I cried so much that I just couldn't focus. In my mother's eyes I was already the outcast of the family. By then I felt sure that if she or my father ever found out what happened to me, that the chances of them ever truly loving me would be lost forever.

From then on my mother tried to get help the best way she could manage. We were both going to try and make things better. The answer was religious based counseling, my first step on a long road to recovery.

Our family situation was, naturally, about as far from a Christian environment as you could get. But here, in my first experience in a climate of healing I felt a spark of hope about getting closer to religion. I will never ever forget the one day when I was in the office my Christian counsel, she took me right into her arms and said she loved me. Then she gave me a Bible. She said "this Bible here is for you and your family."

I did not understand about God, still I kept on going to counseling and looking forward to it. Then one day I was there, the counselor told me that she had to go to another state because her husband's job transferred him. I cried when she left. I never saw her again, but that lovely woman's name was Jackie Watson. And I felt genuine love with her, a feeling that was, at that time, very unfamiliar to me.

Next I was assigned to a nun counsel that was on staff. She was nice enough, but there wasn't the same connection that I had Mrs. Watson. While I continued to reach for some kind of answer my mother stopped taking me. I was still crying out for love, and peace and understanding. My mother was broken inside and couldn't help me now. I knew there was a God. We were taught that He existed. That's it. That's all that was said about God growing up in our home.

I knew enough to trust there was something there, just beyond my comprehension. I knew that things were off base in my life and I had to find the right answers. But I did not know anything else but to look in all the wrong places.

I continued on a path I couldn't control. My relationship with boys left me feeling a little awkward and out of place among classmates my own age. That ever since my father died when I was eleven years old, I found myself attracted to much older guys.

This created a bad situation made worse by my mother. Her attempts to reach out to me, and to all of the kids, was through buying us clothes. Even when I was just thirteen, she had a habit of giving me things to wear that, to say it politely, could only be appropriate for a girl who was much older than I was.

To me, wearing clothes that were sexually suggestive made me feel older and more responsible. And in my view at the time, I welcomed the chance to appear more mature than I really was. But the truth was I didn't care at all about the clothes mother gave me. They were just outside appearance and about me playing a role of a young girl trying to grow up. What I really wanted from her was for once to say "I love you" or give me song sort of quality time. But I never remember any of those things. No matter how she might have tried, her only feeling toward me, her youngest daughter, was contempt.

My need to be noticed and accepted by older men combined with how I was dressed naturally led to promiscuity. My behavior and my outward appearance also had the effect of making me stand out from people my own age. Girls my own age who should have been my friends had no way to relate to me. Feeling different from everyone else helped push me away from any chance of childhood. I admit it was a pretty crazy situation that would have bad consequences.

I start drinking wine, hanging out with the wrong crowd. Then I started having sexual relationships. I was dating older men and met a man named Peter. I thought he loved me because he introduced me to marijuana. The drugs were a welcome escape from reality and the second biggest mistake in my life. But first I'll tell you about my worst mistake, and the day I met Peter Johnson.

It was a cold winter day in Cleveland. I was in the ninth grade walking home from classes into a hard wind. I was wearing leg warmers with blue jeans and penny loafers under a long coat. A voice came from behind me saying "hey girl with the jeans and penny shoes…I want to talk to you." I kept walking and trying to pretend I wasn't hearing it, but he caught up to me. He asked me my name and I remember seeing his face and not wanting anything to do with this kid. I didn't feel anything at all that was appealing. I didn't like the way he looked, acted, sounded, nothing.

Later that evening I got a phone call. It was Jacob, Peter's brother. I expected him to ask me about how I felt about Peter, but he didn't and I was glad about that. Jacob was good looking and older, about 27 or 28 by that time. We had a great conversation and I felt good about him. He said "come on by the house and visit tomorrow." The next day I got to the doorstep asking for Jacob. His parents let me in but let me know that there must be a mistake, that Jacob had gone and moved back to Akron week's prior.

Peter came by my side and admitted that I had actually been talking to him on the phone and not Jacob. Of course, I was not impressed at all with Peter's ability to trick me on the phone. But he stopped me from leaving by apologizing his heart out. I stayed and we got to talking, picking up right where we left off when I believed I was getting along so well with Jacob.

I still didn't really see any attraction in him, but we got used to talking more and more. For Peter it seemed he wasn't just interested in sex, he wanted to talk and learn things about me. He wanted to know what I liked, or what I thought about different things. It was different, and I was looking for love and attention any way I could. I was feeling blank inside, still sad over the death of my father, the only one that ever loved me.

I did not want my family to find out that we were spending time together, especially my mother. I was never sure how she would react to even a minor situation. This whole thing with seeing Peter was a big deal. And as far as I was concerned the less she knew about me the better.

I started sneaking over to Peter's house every day, all the while saying that I was just going over to a friend's house. I was caught up lying, cutting out of school, and began to relish the attention that this boy was giving me. I missed 43 days of school that year. I made my choice and was dropping out of my life, my responsibility at

the school that I hated. I never would see much of the tenth grade.

My absences from school could only be held secret for so long. In time my mother found out about me, and responded that way she always did, by beating me up. She punched me in the eye and screamed that her "daughter wasn't gonna be going anywhere near that filthy house." And I really do think that her genuine concern was that Peter's family did, in fact, have a house that was more than a little messy.

My mother stomped over to the Johnson house and berated both Mr. and Mrs. Johnson Saying "I don't know how you got my daughter into this filth!" She then turned her attention back to hitting me and she didn't stop until my grandmother stopped her.

The state of my life at home just made me want to escape even more. My mother would hit me and throw me out of the house because I kept hanging with Peter Johnson. He kept telling me he loved me, and I thought his family loved me too, because I did not get nurturing from my mother.

Yet over at Peter's house it was so much different than what I was used to. Peter would have nice talks with his mom, his parents would politely speak to each other like friends. Then Mrs. Johnson would have me sit

down at the table with her and ask me questions or just talk like any regular mother would. She would ask me what I liked, about music and television programs, just simple things that my own mother had never cared to ask of me.

One day Mrs. Johnson asked me what I wanted to be when I grew up. My first thought was of my own mother, who complained that the only thing women were good for was typing or being a waitress. But I told Mrs. Johnson I was thinking I could make something of myself in the Army. Well, Mrs. Johnson was so happy with me and so understanding of my goals! It made me inspired just to have that kind of support. I was not used to it and it gave me a feel of confidence and guidance at the same time. I thought to myself "this is my real home."

I don't want to sound ungrateful, or make it seem like my mother never cared for her children. I think she did, and while she was incapable of showing any kind of affection or guidance, she tried to connect with us in her own way. And her way was to take us shopping.

My mother kept right on buying me everything you can think of. And every weekend we would be right there together at the mall. She would help me pick out clothes and never complained about how much things would cost. But she was a person that while standing next to you physically might as well be a mile away in spirit. I believe

she tried, but it seemed the past abuse was too much for her, and I was hurting from the absence of love.

It was easier and easier for me to spend every chance I could get over at the Johnson's house. I remember Peter and I would watch television- I loved it! I'm a TV. fanatic, especially with black and white movies or scary classics like Dracula. Actually any old movie can easily keep my attention.

We were doing more than watch television at Peter's house. While his parents weren't around it gave us the opportunity to drink, get high, and experience what we thought was the freedom to act like an adult. We weren't hurting anybody, and for me it was all about getting away from reality anyhow. Except the reality of the situation was that we were not acting smart.

Chapter 3:

Married Life

At age sixteen I was already pregnant. Peter told me that he loved me, but when my mother learned I was having a baby she hit me and made me have an abortion. I was sad and angry at my mother, and her reaction to the whole situation only made me sure that being with Peter was preferable than being in my own house.

All this time Peter became more and more possessive about spending time with me. I chalked it up as him loving me and just wanting to be with me as much as possible. In hindsight there wasn't much innocence in it. Peter was growing into a completely different person and I couldn't believe it.

One night we were watching a late night show called Big Chuck and Little John. Anyone from Cleveland has seen this show, the hosts are filmed with a studio audience and

they play all sorts of classic movies with ridiculous little skits between the commercials. Well twelve midnight was just about to roll around and that being the curfew my mother set, I got up to leave for home.

Peter was insistent that I shouldn't leave, that I should stay with him and just keep on watching the program. However, there was no talking to him. He got up and hid my shoes somewhere in the house. I cried because with my mother, coming home without shoes may have been worse than coming home late. And it was the dead of winter, I couldn't believe Peter was going to let me go home barefoot in the snow and ice.

When Peter saw that I was actually leaving, he went quickly to retrieve my hidden shoes. He threw them at me and began yelling like I've never heard from him before. I started to run the three or four blocks home. I almost made it to the end of the first block when Peter ripped me down by the back of my coat. I was scared, not knowing what to do by lie there motionless on the icy sidewalk. He screamed "Tracie you are acting just like a little girl! I should be with someone older…" I answered back "Peter, I am a little girl…I'm sixteen years old."

This logic didn't seem to get through to him. So I promised that I would stay longer with him next week. But next week came and his personality didn't change. Peter was obsessive, and growing more and more upset that I had to

be home at night. He started making threats to me and my family, he said he would call the fire department and tell them my house was on fire.

I couldn't believe the depth of his actions to get me to stay with him. I wanted to leave him but I was held to him by a growing fear of what he could do if I tried to get away. Peter started to remind me that he knew exactly where my mother was every minute of every day, he could find her immediately and hurt her.

By now the freedom and attention I sought to find with Peter felt like it had turned my life back into a trap. It was once again closing in on me and advancing beyond anything I could actually control. It would continue to spiral away from me and I couldn't gain any balance for myself.

At the age of seventeen I was pregnant by Peter. Like before, my mother beat me when she found out, then she threw me out of the house. I went to live with my brother and this time I kept the baby, a son, who was born June 7, 1984.

I married Peter Johnson on January 11, 1985. I tried to stay positive about the whole thing, after all, it was a chance to get away from my mother. Above that, since it was obvious I wasn't going to leave Peter so maybe he would calm down and not be so obsessive about me. It was like Peter wanted nothing more in the world than to

be with me. That was enough to get me to forgive him for acting so crazy.

The wedding wasn't exactly well planned. I was washing clothes over at the Johnson house. Peter wanted to know how I could ever want to go into the Army. He could, at times, come off so caring toward me. He said "If you truly want to join the Army, well then I'll go in the Army with you. But please, just promise me that you'll be my wife."

Now the clothes weren't even dry yet, but Peter had me put them on anyway so we could hurry downtown to the courthouse right that moment. I went out of the house soaking wet in the middle of January! Like some kind of off beat romantic movie we hurried onto public transportation and got to the judge just in time. I was worried about getting sick being out in wet clothes, but I admit I was kind of caught up in the moment.

Complete with a ring Peter got from a bubble gum machine, we were married and I was so happy in that moment. Peter promised that he would get a good job and that soon he could then afford to buy a real ring. But I was happy with the ring Peter got for me, even if it was bought from my own pocket change.

Peter told me that I had better keep our marriage a secret. Then he looked down at the ring and proudly said "we can celebrate when we get back home...I'm going to buy some

pink champagne." And he did. We bought a complete dinner from Mr. Hero's, which we shared in his room. Eventually his sister came around and wanted to know what was going on. She had heard that we had gotten married and wanted to know if it was some kind of joke. Peter showed the marriage license to his whole family. They couldn't believe it, they wanted to know why were we sneaking around, and why I didn't tell anyone. And all I could say was because that's the way Peter wanted it.

The news of our marriage was not entirely welcome in my family. My mother wanted to know what I was thinking marrying a "bum" like Peter. She was really hurt that we had just run off the way we did. She said that she would disown me. My grandmother was kind to me however. She invited me over and said she had "a few little gifts" to give me. She gave me a blender and some pots and pans.

But that wasn't all, my grandmother had some advice for me. She wanted to teach me something about life, and it reminded me of when I was just twelve and she would try and teach me about God. She gave me some tips on how to keep a happy marriage. Number one was to be the best wife you can be. Number two was to keep other women out of the house.

She confided that my grandfather, her husband, had cheated on her. She joked about it, but in a way that carried both a serious and forgiving tone. She told me " I can't tell you

that you're right or wrong about getting married to an older man. After all, I married an older man, a good man." She said that a marriage takes work, and that we should try very hard to make the best of it. Then she took an opportunity to say some nice things about my grandfather.

My grandmother never put me down, though I started feeling bad about things. It was more than a little awkward. I was caught up in being someone's wife, an adult. But even then I realized an absence, and that there was seriously something was missing in the experience. I know now that it was guilt. For deep down I had to know that Peter Johnson didn't really love me. In hindsight his idea of marrying me in a moments notice had less to do with any love for me, but more likely an act to spite my mother. I was just tagging along on a trip, it wasn't ever exactly my own life. Looking back this was the worst day of my life. And I was left to consider the future in my wet clothes.

I moved in with Peter and we lived over at the Johnson's house. I did not have a job when I was trying to go back to school to get my diploma. I had a few months to go and my sister in law would come and take me to school so I could finish. Peter insisted that school could always wait, and that the most important thing would be for me to get a job. Since Peter wasn't working it put pressure on me to get our family on its feet any way I could. So I quit school and got my first job cleaning hotel rooms.

This job was another opportunity for me. I wanted to make ends meet and not have to ever rely on welfare. The hours were 8 am to 5pm on Monday through Fridays. I caught three buses to get there since the hotel was pretty far out. I didn't mind the work at all. But it was hard finding anyone to watch my son while I was away.

Peter was always out with his friends and getting high. At first the living situation worked out with Peter's mother or my sister watching him before they went to their own jobs. Then my sister's schedules changed and at that time Peter's family there wasn't much in the way of other choices. Back in those days there wasn't day care centers like there are today. I had to quit that job and be there with my son.

Things did not go well during this time, and they would only get worse. Peter singled me out as the source of his problems and we were fighting every day. He was getting obsessive and abusive. I felt my only defense was to go home, and my baby boy and I moved back home with my mother. When I came back my mother took care of me and my son financially, but she never did say I love you or hold me in her arms and tell me it will be all right.

Some days later Peter called to say he would change in order to give our marriage another chance. We went back to live with him and my mother was so upset with me she told me never to come back. She changed her locks on the

house and the abuse started up again with Peter forcing me to stay with him.

I kept saying to myself if I stay things would get better. It didn't and my mother actually took me back again. Then Peter started to play games to try and antagonize my family. He would call fire trucks or the police saying there was a fire or emergency at my mother's house. It was the craziest thing.

He threatened that if I didn't go back to him he would ruin my mother's car or hurt all of us. He threatened to kidnap our son. I just wanted peace from it all.

Then things got quiet and Peter did actually change. He had finally started acting civil, and there was a difference in his voice. He kept on calling and saying that he was sorry for everything. He was going to try his best to be a good husband and father to our son.

I wanted to believe him so much I actually thought that he was going to provide me the love I was missing my whole life. I did it, I went back to him and was once again living at his parents house. I believe, in general, that people can change.

I am not proud to say, this went on for years, abuse and forgiveness, running back and forth from my mother's house and over to Peters. Peter was staying all night. He

took liberties with the car my sister gave to me to learn to drive and that was that. There was a bad pattern going on. I turned a blind eye for most of it. He was out with other women, drinking, and when he was home he was hitting me more and more.

Chapter 4:

Escape Plan

I was losing hope of getting anything together in my life, watching it all spiral down. Even worse I felt that in my poor condition I couldn't possibly be a mother. When I truly felt there was no hope I grabbed a bottle of sleeping pills. I went downstairs and brought myself a glass of water. This was my solution to what I felt was no way out of being a miserable failure.

As I swallowed the pills I wondered if anyone would miss me. But aside for that moment of wondering, I felt glad for the first time in ages. There was a strange place of relief in my actions. Would anyone miss me? No, I was certain the answer was no. After the trouble I caused myself and others, people would be relieved that I was finally gone.

But it wasn't my time yet. I was rushed to the hospital and they pumped my stomach. Peter was now by my side.

He was scared and promised to commit to our marriage, and to get a job. He helped me sign up for welfare, but he set it up so the checks were sent to an address of his friend, explaining that checks wouldn't be delivered at his mothers address.

Soon after, Peter told me the first check was stolen. My older brother had let me change the address to his house so I could receive the money to get me on my feet. But he called me a welfare queen, and I felt really bad because of it. I was starting to wonder what sort of purpose could I serve in this world, and why I was still alive.

I was feeling a change, a small part of me was in there knowing I had a new chance on life. So I started to think about the kind of changes one has to make to get in the right place. My whole life has been confusion, I just hoped for some clarity to see things better.

I knew I was at a disadvantage. I did not have a choice at that time for I did not have a job or high school diploma, I had my baby son and I needed to take care of instead of depending on other people for support. I did not like the idea of leaving my baby with anybody, but my sister and mother would watch him while I try to go back to school, and I started looking for housing.

I had a little money for a one-bedroom apartment, and the property manager let me move in anyhow. I thought

Peter was going to move in with me, but he was living with another woman. Looking back, it was obvious I wasn't exactly thinking too clearly at all. I asked Peter to come back saying I got the apartment for us, and that we can work together for our son. He wouldn't move in, but told me he could spend the night sometimes. I felt really bad I did not know what to do any more. Not even Peter wanted to be around me. I was completely down, beaten, and I remember feeling so completely alone in that apartment without furniture.

I felt I needed to get back my deposit, and the property manager called people who knew me to come and get me because I was losing my mind. My brother's wife came to take to me, and I felt bad because I did not want to face my family. Most of all I was scared and ashamed to see my mother.

But then my sister called me. She was in the Army and stationed over in Maryland. She wanted me to move to her place so I could help her out by watching her two young children. Her babysitter had left and needed someone to watch them during the days. I wasn't working at the time so I thought it would be a great idea. Finding that I was actually leaving Cleveland, Peter found new interest in our marriage. He decided that he was coming along too. He was talking about giving our marriage some new life, and that we would be much better off in the new surroundings.

I was thinking while arriving in Maryland that this would be a change for the better. And it was a good start. Maryland was beautiful, and we were getting comfortable at my sisters place just off base. She lived in the suburbs, which I thought were amazing, just so nice.

Things were so much different in the South. Everyone was friendly and warm, there was a positive atmosphere that I found both welcoming and unfamiliar. It was a different world from what I had experienced back in Cleveland. In Maryland there were still a lot of good jobs around and a lot of optimism. Looking back, I think that even Peter was affected. He told us that he would try hard to find work, and that if we saved money we could even maybe buy a nice house in the suburbs just like my sister's family.

I found a job as a waitress in a pizza shop. It was called the Pizza Oven Inn and it was right on the same street that my sister lived on. They had the most delicious pizza and wonderful salads. It was my job to get the salads ready and I felt responsible and appreciated there. It was my first job and working there went a long way to restoring my confidence and overall feeling of self worth.

Peter, meanwhile, was having no problem trying to hold on to his old self. After six months my sister's husband was still trying to find him some work. Peter resisted change. And it really didn't matter because it turns out he wasn't

even allowed to be in Maryland in the first place. He was on probation for his troubles back in Cleveland, and he ended up having to go back to Ohio.

I wanted to stay in Maryland. I was scared of the idea of not having Peter around, but somewhere inside I had an ounce of resolve, to make this new life work for me. I thought about going back to school to get my diploma. Although there was still a whole lot inside of me that felt unsure about myself. That is certain, because then one day Peter called me on the phone. He said to get back to Cleveland as soon as possible.

Having his parents get thrown out of the house made him worried, and he said he wanted to make a change. He said he was going to get a job and apartment and do what is best for our son. Peter told me if I don't come back our marriage was over. I am ashamed to think that I was still holding onto the illusion of our marriage and thinking things would somehow work out.

I was scared and feeling confused. I told my sister about what he said. She said that she couldn't live with all of my problems and that she had problems with her own husband. In fact, she was caught in the same abusive spiral that consumed my own life.

All of a sudden her marriage looked to be unraveling, and she was in no shape to give me any kind of support. The

perception that she and her family having that perfect life in the suburbs was shattered and I felt out of place. So I quit my pizza shop job and gave up on school. I came back to Cleveland even though I knew everything I ever did was a big mistake with no way out, and I said "Oh God when would the nightmare end."

I try sometimes to think where I could go to stop the confusion that was going on in my mind. Peter was saying all the right things, that he would make it better. I called the clinic thinking if he got some help that things would be okay, that we could fix all that was wrong.

Peter and me went to counsel together, along with my mother. But things got even worse. There was tension between Peter and my mother that could not be resolved. She saw Peter for what he was, and told me I needed to leave him alone and that he will never change. The first thing I decided was that it would be a bad idea to bring any more children into this world with the turmoil that my life was in.

I went to the doctor to get an IUD for birth control, but two months later I had a miscarriage. At the hospital they told me that I was already pregnant when I went to the doctor, and that the IUD killed the baby. I was shattered at the thought of this. At this time in my life what I needed most was love and support. Again, all I got from my mother was anger and bitterness.

Peter was not allowed to come over to see me at my mother's house. But I still wanted to see him. We had a plan to be discreet. I told him to ring the bell only one time so I can know he was outside waiting and sneak down. But one day he kept ringing the bell several times in a row and didn't know my grandmother was staying at my mother's house. My grandmother went to the door and hit him with a stick. She chased him down the street, my sister had to run and get her back in the house. I was afraid to come out and was ashamed from the whole thing.

After this incident, everyone was mad at me saying that I was causing harm to the family. My mother kicked me out of the house and I went to live with my brother. I game Peter my welfare checks to get an apartment. He promised me that it would be a good environment for our son. It was a lie. He just took the money and spent it on drugs and alcohol. Eventually I moved in with Peter's parents place and slept on the floor with my son. Peter was living with another woman, but he would come over his parents to see us. I still accepted him as my husband.

CHAPTER 5:

PARENTHOOD AND ADDICTION

At the age of 22 I got pregnant for a third time, and the child was born on Jan 6, 1988. She was a beautiful baby girl that I named Nicole. I was happy, but Peter was bitter about it all.

When I was pregnant Peter told me the baby was not his. He didn't want the baby and had nothing but bad things to say about my pregnancy. I really feel that's when a kind of spirit of rejection entered the womb. That Peter could influence a bad feeling by rejecting the right to life of his own daughter. This goes to show you how a generation-long curse came into being. My mother and father did not want any more kids when my mother had me, but thank God, that curse stopped here in the name of Jesus.

Looking back, it is not surprising that nobody was happy about the new arrival. There were no kind words for my

baby girl. This had a draining affect on me, and with all the depression hitting me, I felt like giving up. I tried to talk to my family about what was going on, but they would laugh at me and call me crazy, or worse, that I was pathetic and worthless.

My self-esteem was very low. The family told me that nobody would want me, since I already had two kids. I felt uneducated and depressed. Each day, each hour, the depression consumed me. I was left with two small children and something less than a part time father. The kids were my only bright spot. Trying to raise them the best way I knew how brought me joy. I love them so I try all I can to protect them from the hurting and pain I was going through.

I took my children everywhere I went. You want to think about the future when you have kids. You want to be better for them. I went back to school. It seemed the natural thing to get on the right track.

My past decisions were always going up against me though. It's hard to explain how you can let someone else have so much bad influence over you. It's a bad and helpless feeling to be in that situation.

Peter would continue find ways to infiltrate my life and my decisions. One day in school I remember getting a note from the secretary. The school office said there was

an emergency at home and that my brother was on the phone. This made me worried and my mind was racing wondering what was going on, like maybe my mother or my grandmother were hurt. When I got on the phone I was surprised that it was not my brother at all, but Peter. He begged me to leave the school and meet him downtown at a department store for lunch.

I left school and met him and he wanted to talk to me. He didn't have any money so I had to buy his lunch. He said that he wanted us to be together as a family, and I didn't know exactly how to react, but I still felt that marriage was a powerful vow to God, and I listened on.

Things sounded positive, or at least I wanted them to. Peter got a job for a construction company. Once again my mother did not want to have anything to do with me and changed her locks yet again. It was her way of making sure I didn't come back home, that I was on my own and left to the consequences of my decisions. She still bought the kids what they needed, and took financial care in that regard.

So I was back living with Peter, back to the way things used to be, which was not a good thing at all. When it appeared that everything started to once again unravel, I kept telling myself this marriage will not work. There still might be a way to find a way out of this. Peter lost his job and started receiving social security checks. I was still

receiving welfare. Our relationship was feeling the strain of debt and living on government assistance.

On a day when the children and me were staying with Peter's parents, Peter had just got back from cashing his social security check. He went up in the attic where me and him and my two kids was sleeping. He was acting strange and spoke to me with a serious tone in his voice.

The attic was dark and cold, a little light came in, but there was no heating. The only warmth in the room came from an electric heater plugged into the wall. He told me to leave the kids downstairs where his mother was. Again, I did not like leaving my kids, but I went up to the attic to see what Peter wanted.

Peter stared at me and let me know that things were going to be different. He told me he was going to give me some money for the children, to take them out shopping and have fun. But, he said, before I left, I would have to try something. He promised me that it would make things better. And that it would make us both feel good inside. Then he showed it to me. It was crack cocaine. I told him I did not want any, but he insisted. He said I won't regret it. He said it will help me, and that I should just try one hit.

The day was March 19, 1988 when I had my first experience with crack cocaine. It was like me life was taken over by something else, and in a moment I felt I

was floating through air. I lost complete connection with my life and surroundings and that was a welcome feeling. There was a beautiful song ringing through my head, like birds singing, and my head was drifting up toward the ceiling. It was an experience that is hard for my words to describe.

My connection to the real world would come back at times, because I kept telling him I got to go back downstairs to see about my children. Then as quickly as before, I was back floating once again. Thank God his mother was watching them and until 8am the next morning I was still high.

As I started coming down from the high, I felt like I was under Peter's control more than ever. He told me that what we did was very important and serious, that now no matter what we wanted in our lives we would need more crack. I was already desperate considering how I could live after that experience. I was immediately torn. I was worrying about what I knew of the dangerous patterns of addiction measured against the affect it would certainly have on my children. My deep feeling was that I couldn't possibly go on without crack, and the false sense escape that it afforded me.

Before long, Peter and me kept smoking crack all day and night. When I did see my precious little children I felt really guilty and I could not look at them in the

eyes. My guilt was heavy and I had nobody to blame but myself. I knew that I could leave them all night long with my mother in law. She would not hurt them, but the point of it all I did not like leaving them ever. And now my constant concern was the drug. I knew it was horribly wrong, and a couple days went by I tried to stop thinking about crack. But I the idea of breaking the desire was all powerful against me. I smoked whenever I had the chance and my kids were left for hours with Peter's mother. They were forced to live each day without me around to nurture them.

The guilt of what I was doing to my kids caused me was strong motivation to break out of the habits I was caught up in. My life had become a constant pattern of mistakes tempered with desperate attempts to change. My solution to get away, to change, was basically the simple idea of surrounding myself in a new place. I thought that a new place to live could inspire new chance at life.

I was exhausted and burdened with the disgrace of being addicted, but I willed myself for strength, and gathered up the clear state of mind to get going. I called to see about some low-income housing I was seeking. The housing manager called me back and I was overjoyed. He said that a two-bedroom apartment was ready for me and my kids. It was wall to wall carpet and rent was $435. I was only to pay 23 dollars a month. The security deposit was only forty dollars.

The apartment was beautiful. My sister in law helped me move my clothes into the new place. There was no furniture or beds, just me and my two kids. Peter moved in after getting a job with another construction company. Then after only a month on the job he got fired, being accused of stealing from a house that they were pouring cement in the driveway.

I was still getting welfare to support my kids. I did not like leaving my kids on anyone at the time, and I didn't want them out of my sight. There was not a lot of day care centers like there is today, for my baby, she was only one year old and my son was spending half day in kindergarten. I felt like I didn't have much choice but stay home with my children. I took them everywhere I went, they were my gift that God had provided me.

Peter didn't feel the same about the children. He was staying out real late most every night. One time I thought a change of scene, getting out of the house for one night would help. We stayed at a hotel. He told me he wouldn't stay another night back at the house, it made him feel terrible because it was the reality that he was supposed to provide for our family, it was something he just could not bring himself to do.

So I dropped the kids at my mother's house and paid the hotel room for two days. We stayed there while he figured out what to do with us. Time was running out, we couldn't

live at the hotel and I wanted us all to go home. Peter's mind was racing, and he was acting strange. I urged him to drive us back to our apartment, but he answered that the other women he was seeing would get mad at him if they found out we were together. He wouldn't let me in the car, so instead he walked me to the bus stop so I could return to the house by myself.

Just then a car sped right out of busy traffic and up on the sidewalk. It was speeding straight for both of us. It happened so fast. A terrible screeching sound of burning rubber tires was shocking to hear, and it left me there standing near the curb, frozen. It was one the other women, and she nearly hit me with her car. I turned to see Peter running down the street. He tried to flag down the driver of an approaching bus and I went running after. I could hear the car's engine loud behind me but I didn't look back. I got on the bus and remember feeling so bad. I got my kids from my mothers house and I told my sister and brother what happened to me, about Peter, and they laughed at me and said I am crazy to be running from the other women, pointing out the obvious fact that I was Peter's wife.

When I met up with Peter he had found escape to his mother's porch. And here he was on his mother's porch screaming at me. He told me that I was going to get him in trouble with his other women. He said that the woman who almost killed us had a right to be mad, because she

took better care of him than I did. He blamed me for not doing a better job of supporting him, and that she could give him a nicer place to live.

I was so ashamed my self-esteem really was low. I felt like just killing myself, felt so much pain and rejection. I went to stay with my mother again and was depressed enough that I left the apartment for Peter to keep. He stopped paying and I lost that beautiful apartment.

CHAPTER 6:

A DETOUR IN ALABAMA

Summer was fast approaching in Cleveland. Each year the change in season makes everyone optimistic for the warmer weather. This is especially because the winters can be so harsh. Even spring can be down right cold up here. But the last snow day was behind us, I was glad but it turned out I wouldn't be around anyhow. I was with my kids and we were headed down to spend summer with family in Alabama.

Now I was well used to the weather in Ohio. I could tolerate the cold, the humidity on the hot days or the never-ending rain storms that come across Lake Erie in the fall. I could handle those things. But I was in no way prepared for the heat down south.

Every day down there was scorching. There were no cool rains to offer any relief at all. The air in Alabama was

heavy and muggy like I've never experienced. It was hard just to breath. My family was happy to have me visit, however, and I was enjoying their company. My aunt and uncle loved spending time with the kids. It was nice getting to know my cousins.

Then I met Shannon. She had what I would call a bright, friendly personality that made you want to like her right away. Before I knew it we were racing along in her car. Shannon promised that she knew every dope dealer in the state of Alabama.

All at once I was experiencing the excitement, the fears, the addictions, all those same feelings that I wished I could just bury in my past back in Cleveland. It was all going by fast now, and Shannon was keeping her promise. We were walking through one of the nicest houses I had ever seen. I was meeting all kinds of people who were very polite, even genuinely glad to meet me, the new friend of the party girl, Shannon. Then just like that it was on to the next place with even more people to meet. It was all so crazy. These people were drug dealers and they had the greatest houses, all kinds of popularity, friends and the nicest things imaginable. It felt a world away from the truth. There had to be a dark side of it, the murders, the lies, prison and the countless lives shattered from addiction.

At the last house I remember meeting the young lady who lived there. She was very nice to me, in the same

hospitable way as everyone else I had met. She offered me a glass of pop, but I politely declined. Long ago my mother had taught me that it was not polite to accept things in other peoples homes. Shannon disappeared into one of the many bedrooms and I jut waited. I talked with the young lady and saw that she had something in common with everyone else I had met that day. I could see in her eyes she was just as sad, lost and empty as I ever was. The fast money comes at a steep price, I thought. I said "Lord, this is not the way to live."

In the car ride back to my aunt and uncles Shannon told me about how easy it was to make a living by selling. The idea of making money that way was easy to resist, I thought. I didn't say much back to her, but for me it was obvious that I did not want to be a part of that lifestyle. I stayed in Alabama for that summer but managed to good job of staying out of trouble and avoid Shannon. I felt bad for it, because like I said, you wanted to like Shannon.

That fall I was experiencing those first cold winds off of the lake with everybody else in Cleveland, Ohio. The phone rang and it was my cousin. She told me that the young lady I met who owned the nice house was killed. I remembered how she seemed so lonely. I felt so sad for her; in many ways her world seemed so safe from the dark side, so alluring. Why would someone want to hurt this girl? Not knowing what more to do, I prayed to God.

CHAPTER 7:

A PRISONER IN MY OWN HOUSE

Soon I was back together somewhat, and got another low-income place. Again, it was a great place that was perfect for me. There were two bedrooms and I was feeling some hope for us. The kids and I moved in and soon enough Peter came with us also. I couldn't stop Peter moving in with us, and at this stage in my life I was lacking the will to say no to him. Still, I knew I needed help out of this situation with Peter Johnson. I was making the same mistakes and searching for answers to my problems.

I try to read the Bible but I did not understand it. I just stopped reading it, saying to myself I know it's a way out of this terrible circle that I found myself trapped inside.

The man I called my husband was growing into someone else entirely. He was acting strange, and even more threatening

and more controlling than I could ever imagine. Peter would make me and the kids look at television with him, and warned there would be serious consequences if we did otherwise. I remember him forcing us to stay right there and watch, and we were not allowed to move even an inch from our spot. He was usually most obsessive about us having to watch Hawaii Five-0 with him.

During these forced viewings I was seriously afraid to move. So afraid I wouldn't even ask him to go use the bathroom. He didn't want me to do anything but watch. It was crazy, and I couldn't bear it. I had to sneak around to clean the apartment because he didn't want the place to be clean.

I was shaking all the time. Even when I cooked dinner, he made sure that I had to do it in an exact way or else he would go off. One time for dinner we ran out of ketchup. He went into a rage and started to beat me because of it. I ran outside for help and the police came. They didn't take him to jail but told him to take a walk. A couple of hours went by he called me from his sisters house saying he was sorry, he wanted to come back home. I was afraid to say yes and afraid to say no. I ended up telling him to come back.

When he did come back, he said he wouldn't ever hit me again. But that was a promise he could not keep. When the abuse started again I was in fear that he could actually

kill me. One night he was threatening and came toward me and I reacted in a way I never though possible. It was like I turned into someone else in order to save my life. I ran away and he followed. That's when I grabbed a knife and cut him on his back and hand. At that moment I was afraid of my own self, and that I was going to kill him.

Thank God I didn't hurt him worse, he ended up in the hospital with stitches in his hand and back, and when he was released it was Peter who apologized to me. He said that it was his fault, that he provoked me into stabbing him.

I was so sorry and could not believe what I had done. And although we made up, I was still so scared, afraid that he would try to hit me again. That very next day he became violent again, and started screaming at me and threatening my kids. I was once again in fear of our lives. I had to sneak out of the house to stay at a women's shelter.

The next morning I went to get a protection order against him. They took the report over at the police station and on the way back I ran into Peter on the bus. He started to harass me and told me that we ran into each other for a reason, and that reason was that God wanted him to see me.

I kept saying to myself that that was a lie. But I was so afraid at that point I jumped right off the bus and ran to the police station again. I stayed at my mother's house and

my mother would complain and say she was going to take my children from me. When I gathered the courage I left her house again and went back to my apartment and made sure I locked Peter out. When I got back Peter immediately broke in through the window. He said he wouldn't hurt me and to let him stay there. I could not overcome my fear of this man. I couldn't say no to Peter and soon enough I was once again living in shadows of abuse.

Peter could be prone to sudden rage. He could be calm and normal one moment and then just go off completely. He made sure that I should always be in fear, and that he had the power to end my life at any time. He would chase me through the house with a knife. He would threaten to kill me, but he didn't did keep that promise either. It was as if he would prefer to have me scared and under his control rather than dead.

To get by financially, he resorted to taking food out of the freezer to sell it. He told me that I better not leave or else he would do something serious. He took my house keys just to make sure that I could not leave. Like my mother before me, I was a prisoner in my home, afraid to go out of the house.

I also was not allowed to talk to anyone on the phone. I could not go to sleep whenever he was awake because he would keep me up and tell me sleeping was disrespectful. It was like torture for me. If I did fall asleep Peter would get

mad and immediately start screaming, telling me to watch television with him, like when we were first dating. I would be 2am or 3am and I just wanted to be sleeping. I was feeling sick, disoriented from being tired. And he would say that I was faking it, that I was half out of my mind.

Some days Peter would lead me and the kids out of the apartment and over to his parents house, and he would start screaming orders at us over at their house. I remember being so powerless that I couldn't stop shaking. Peter's mother would put alcohol on my forehead, saying it could calm me down. She told Peter to stop picking on me and he would just walk out of there, but not before warning me not to go anywhere. I had to stay there until he came back.

I did not want to do this anymore, I didn't want to run and I couldn't stand the ridicule. I finally said to myself that I need to make a change. So I called legal aid to find out about getting a divorce. When I told my mother about the call, she said to get on with it, because the relationship I had with Peter was not a marriage.

And so I followed through and went to file in April of 1989. They told me the divorce would be final in July, and I stayed with my mother for a few months and still kept the apartment. The rent was only twenty-three dollars a month.

Peter worried that he was losing out on his chances to control me, and he started picking fights with my family.

He said they would have to pay because I was avoiding him. He started going over my brother's house and harassing him, my sister and her husband.

Peter went down to the probation court and tried to get my entire family in trouble, making up lies about everyone committing crimes. It reminded me of the times we were dating and he would call the fire department. When my family went to the court they threw everybody out and said they didn't want to deal with this mess. I didn't go anywhere near that place, I knew that Peter was just trying to target me. He told me whenever he did see me again he was going to try something.

Days later Peter called me on the phone and told me to go with him back to the apartment. I was afraid but told him that we are divorced now, that I couldn't go back. He then said that if I didn't go back that he would do something that we both would regret, I looked at my son and got afraid. The same familiar feelings of hopelessness were welling up inside me. My prison was psychological but still real. I knew I would be leaving to go back with Peter.

I'll never forget the look in my boy's eyes when he heard that we were going back with Peter. He looked so confused, not looking to the left or right, but straight ahead at something far off. I didn't know what to say anymore because I felt like I didn't have a mind of my own. I just

went. When I got to the apartment Peter said that this is where I belong. Then just like nothing ever happened, I started looking in the paper for a living room set. The apartment needed furniture.

Even though Peter resumed his habit for staying out all night, I on the other hand, was once again forbidden to go anywhere. He started taking my clothes and selling them. I didn't have much to begin with. He sold our kids clothes too. He just didn't care what he did, as long as he could get money for drugs and alcohol.

At home I was feeling disconnected. I didn't think that anyone could understand why I let myself get controlled, or the hurt that I was feeling. I thought about what led me to this place. All I really ever wanted was some love and affection from my mother. I thought about her every day. I wanted for her to not be mad at me. If I could only experience that love, I could be stronger, and I could have changed things.

I always imagined that she could give me a hug and tell me she loved me, and that things would be all right. She was still in a lot of pain from dealing with the abuse and sudden death of my father. She suffered her own living hell and did not know how to deal with my own situation. That's because she had her own problems to solve in life. She needed to learn how to heal herself.

Still, I believe she took care of me and the kids the best way she knew how. She claimed them on her taxes, she bought them clothes and showed her love through material things. I thank God for her support when we so needed it. I tried to give the kids what they needed most, just trying to give them love and affection the best I knew.

Now looking at myself as a mother, with all of my faults, I still knew that my first priority was to reach out to my children and to be more understanding. Through all the bad situations, I didn't want to down grade my children, I kept trying to make things work out but I only kept failing. Now I know it was because I did not know the Lord Jesus Christ as my Savior, that essential ingredient was sadly absent from my life.

On a positive side, with there being nothing much of value around the apartment to steal, Peter was staying around less and less. It offered me some brief freedom to think more clearly. So I thought about making the best of the future.

I tried to sign up for the army, thinking that was an opportunity to make the best for my family. I could picture myself becoming successful in that kind of atmosphere. And even though I didn't have a high school diploma, the recruiter I met with said they would let me join.

I thought about making it through basic training and getting my GED and getting things on track. But there was much self-doubt, and there was the reality of my situation. I thought about my kids and started to worry about them. With my mother busy with work, and their father a drug addict, there was nobody I could trust to watch over them. I wouldn't be joining the army after all.

Soon after, Peter threatened to kidnap my son if I didn't go to live with him at his parents. He came over to the apartment one day and grabbed my son into his arms, then ran down the street carrying him. I was in shock, feeling scared for his life. I have often seen Peter like this, unpredictable, just out of control with anger. We chased him in my sister's car and that God he eventually stopped running. He handed me my son, but just then Peter slapped me so hard he chipped my teeth. But all that mattered to me at that moment was that I had my son back in my arms.

CHAPTER 8:
GANGS AND DRUG MONEY

The nightmare was like a rollercoaster ride, slowing down briefly only to start right back up again. I just couldn't sever my ties to Peter. My sister asked me why in the world would I still even go near him. After all, we were divorced. She wondered how could I love him so much. What she didn't understand was that I was just plain afraid for my life. Love had nothing to do with it, this was a relationship about control. People who knew him even told me he would hurt me, but still I forgave him. I prayed to God that He could change him.

Peter was back in force, back at the apartment and using crack cocaine at every chance. One night he brought me some and told me to take a hit. It had been two years since my introduction to crack in 1988. I knew this could be a death sentence. I asked him please, that I barely escaped addiction the last time, that I didn't ever want to do that

again. He said to just try it, and that he would make sure that I would be okay. He said the same things as before, all of my trouble would be over. He knew me well enough. Even coming from Peter's mouth, I wanted more than anything to become numb to my feelings of fear.

So I tried it again, and the days were filled with more and more self-inflicted pain. Of escape from the reality and falling right back down to earth. But that wasn't all, one night Peter brought in some strange men. He said that I had to have sex with them. I refused, but he took me aside and said that I have to sleep with them because we just smoke crack every day and it was time for me to pay up. I felt so ashamed I cried, and I tried talking with Peter, pleading that I couldn't do that. But then he got serious. He said it was either that or my life would be over.

I understood what that meant. When Peter took that tone I knew better than to fight him. He was not capable of feeling guilt. I think he truly believed that the violence toward me was justified. Everything was my fault, he didn't care about any consequences, only the drug.

I listened to Peter. I did what he said. After it was over I cried and felt disgusting. Peter told me to take a shower and I did. He appeared to finally come to his senses, he said he felt horrible and that he was sorry. He said that this kind of thing would never happen again.

The next day the lady next door came by the apartment and told me she was embarrassed at Peter for what he made me do. She said that the whole building was talking about it. The thought that people knew what I had done and were talking about it made me nauseated.

I was ashamed and worried but Peter said not to worry. Once again he reassured me that it won't happen again. But then another neighbor lady came over with some crack, and shared it with us. She used our apartment to hide the local dope boy's guns. It was scary, and I am ashamed that I felt powerless to prevent this in my own home.

Soon after I was told that I would have to sleep with the same men again. Peter said that if I didn't that they were going to kill me. One man had a gun on him and told me to "pay up" or lose my life. He pulled my hair and tried to drag me into the bedroom. I saw that the kids were looking in on this mess, their eyes showed they were scared that I would be hurt. Then Peter noticed that the kids were awake and quickly got them in their bedroom and locked the door. My life was not my own.

Chapter 9:

Close to the End

I couldn't bear to think about the person I was becoming. I hated what was happening. The guilt made me think I needed the drugs even more. I was ignoring the needs of my own children and the things they truly wanted the most. I was trapped, going in a terrible circle and I didn't see a way out of the whole thing.

I had thoughts of running back to my family, but there was just too much pain associated with that place. I remember feeling like they would just denigrate me. Meanwhile the stress of having all the guns in this house made me so afraid. I remember saying "God help me" and shortly after I found the resolve to be on my way to the probation court. I was going to try and tell them what was happening to me.

I met a lady standing at the bus stop, waiting with me. She was just waiting on the bus too, and we started talking.

She asked my name and gave me her phone number, asking me if I knew the Lord Jesus Christ as my savior. I said no, and right before the bus pulled up she prayed with me.

Her name was Nicole. And now I know that God was speaking to me through her. When I needed to talk to someone, that woman was an angel.

The next day I called her and she prayed with me over the phone. She asked if I had ever been to the Red Lobster. I said no, and that it always seemed like a place that I could never afford. She laughed and took me there on her treat. There Nicole asked me to receive God in my heart and life. I said a supper prayer, and I said it by faith afterward. I felt good, yet I still did not understand. We ate our dinner and she took me back home. Nicole said any time I needed to pray just to call her up. She promised that she would pray that God would lead my way.

Peter was back at the apartment. Knowing I was out with a new friend, he wouldn't leave me alone about it. I went from feeling the height of great hope and joy to wanting to kill myself. I thought about drinking bleach and taking every kind of pill I could find, but just couldn't go through with it. I saw the phone, and called. Nicole and some of her friends came over and prayed with me. I felt so much better. They told me God would show the way out of this hopeless situation.

Peter came by the house later with crack cocaine and told me to smoke some. I told him no, that instead I wanted God in my life. He said I should at least try it for one last time, for old times sake. He wouldn't leave me alone about it. But I felt strange all that day, something kept telling me to get out of that place. But with the dangerous combination of my weakness and Peter's persuasion, I ended up staying there anyhow.

Peter and I smoked crack all that day. He brought people over to the apartment. That's when my chest started hurting. It was pain like I had never felt before. I tried to ignore it at first, but it was too much. And it kept getting worse.

I was trying to tell Peter that something was really wrong with me, and he told me I just needed to smoke more. I didn't know what to do next, so I just ran out of the living room and into my bedroom feeling scared and alone. My only relief was in knowing that my kids were spending the night at my mothers. I was grateful that they didn't have to see me in that state.

By this time I was completely in a panic and going out of my mind. I couldn't shake the urge to hide in the closet. Then I was overcome by the feeling that I was trapped; that I needed to jump out of the third story window just to escape the pressure in my chest. There was no way out of the confusion I was in. The window was too high for

me to get though. My last resort was to go back and tell Peter that I was dying.

I made a desperate plea to an old man who was with the others smoking crack, struggling for the words to describe the weight in my chest. His response to my suffering was no different than Peter's. He said that crack would make me feel better. I took some deep breaths, went back to my room and tried to lie down by myself. That's when I heard a voice inside. It was saying to get up and get help, and that I would die if I didn't.

I screamed, agonizing that I needed to go to the hospital for help, but Peter was busy with the crack, and told me to wait. With the last of my strength I ran into the bathroom and I just couldn't control my body. My insides were doing their own thing and I started to vomit uncontrollable. I couldn't feel my legs.

Realizing I couldn't stand up I cried out to Peter who had finally come over, and I pleaded with him to call 911. He said no because he was afraid the police would take us to jail for the drugs, so he called his sister who was ten minutes away.

His sister finally got there and was able to rush me to the hospital. I kept passing out and the only I don't remember much beyond that. The one thing I do remember was the voice. When I was in the intensive care, I heard a voice

saying that it is not my time to die. I should go back and live. It said was a purpose for my life.

I can remember wondering what kind of purpose could I serve. I cried, feeling confused and so ashamed that had if I lived, I would have to face my children. Worse, I would have to see my family, those who laughed at me all of my life.

When I came to, there was a nurse standing over my bedside. She said my name. "Tracie we almost lost you," and she explained to me that my heart had stopped. I was 24 years of age in August of 1990 and I had suffered a heart attack.

I stayed in intensive care for three days with tubes coming from my nose and mouth. Nobody knew for sure if I would be able to walk. The nurses were very caring. They washed me from head to toe and my family came to see me, just about the same time Peter showed up. Shouting and fighting broke out right away between my family and Peter, and there was pushing, punching, shoving and yelling all around.

Peter waved some money around and said "look, I have fifty dollars, I can take care of her and make things better." By now my family had heard enough of Peter. My mother grabbed his shirt and began hitting. My sister was there, trying to pull my mother off of him. Finally the nurses

calmed things down. They told my mother that Peter wasn't worth going to jail for. They let Peter get away, and away he went running out of the hospital.

Some days later I was well enough that they released me from intensive care and into a regular room. I was glad to finally get the tubes out of my nose, and the doctor told me they still had to keep an eye on me to make sure I was okay. I felt different, like things weren't exactly real.

There was good news, the doctors were optimistic that I would soon be able to walk. One doctor said I needed to gain weight before they could release me to go home. I weighed only 90 pounds and at my height, 5'4" they said I needed to weigh 125. I had a no salt diet and they kept weighing me every day. It turned out I needed a feeding tube to eat, and that was uncomfortable. But things got better. When they discharged me to go home I was feeling fine after gaining back some weight.

Chapter 10:

Nicole and a Silver Lining

The nurses said that I should be very careful, to rest, and that with help I could start to walk. But first, before I could leave the hospital a police officer came to my bedside. He was asking all kind of questions about Peter. He wanted to know exactly what had been going on at the apartment before I had gotten sick.

I was so upset with myself, angry, and most of all scared, that I couldn't tell him the truth. I was there looking up at my mother, and all I could think about was that I was a tremendous failure. I just couldn't bear to see her mad at me for all of the mistakes in my life. I felt weak, and more scared of Peter than ever. I looked over at the officer and I lied. I told him that Peter had a gun, and forced me to take the drugs with him. The officer copied this in writing for his report. They got a detective involved.

Just then, a second voice chimed in like singing. It spoke that God will know. After I heard that soft voice, I walked away and went outside to the car. We finished packing up my belongings and it felt right. It was a normal day when we started, but by he time we got outside the wind blew across my face and I heard several voices all saying "hurray, she is getting away from crack cocaine!" As I took my last steps out of the doorway to the apartment and I never looked back.

At this time we were getting all kinds of threatening phone calls to my mothers house from Peter. But to make it all worse, the drug boys came calling. The drug boys were Jamaicans who had just recently moved into the area. They were supplying drugs and guns. They said that I owed them money, that I couldn't hide any longer and that they would come to kill me. A police detective was watching our house but I didn't feel safe.

I wasn't exactly sure what they had going on with Peter, but there was a perception that my family had money, and they wanted it. My mother was considering sending me away to live in Alabama when God stepped in and gave me strength. One day Peter and some of the Jamaican gang members came by. For ten minutes they argued and finally one of them pointed a gun at my mouth.

I was frustrated and sick of being afraid in my neighborhood. I said to them "just go ahead and shoot

The simple truth was that Peter didn't need a gun. Being under the control of fear, I simply did anything he told me to do. I was willing to lie to myself and everyone else about my problems. Still feeling confused and lonely, I stayed close by my mother at her house. I did not know what steps to take next, so I called for more healing.

Nicole and her friends who pray with me came over and we kept on praying again and again, holding me and my children together. They told me about a Christian television broadcast that was called TBN and I started watching. After two weeks of watching and learning about these Christian programs I got stronger in the Word of God. I knew that I had to get my life back in order. I needed to get the rest of my things out of the apartment. I needed to break away.

I went back to the apartment and the neighbor lady came and spoke to me, asked me how I was doing since I got out of the hospital. She said that everyone was talking about me getting sick. I assured her that I was doing fine, and she asked me if I was moving out. I replied that she could have the furniture, and she was happy to take it.

My sister and brother in law were helping me clear out of there when I heard another voice. It was clear in my head, and it was telling me I belonged there. It said that I should stay there and that I could get better with more drugs. And the voice said that nobody would ever know if I just tried it again.

me, I am tired." Peter must have felt sympathetic or just resigned that I wouldn't ever give him any more money. He told me not to worry, that he would take care of his problems with the drug boys. I never saw the Jamaican's again. And Peter was arrested and sent to jail in September of 1990.

My sister called me from Germany and since she would be coming back to Maryland, she asked me if I would be able to watch her three kids. She and her husband were about to get separated, and I was really still in the process of recovering my health. This was my chance to show some responsibility, and I didn't want to let my sister down.

The plan was that I wouldn't have to go to Maryland, but that her kids would be coming to stay with me at our mothers. Everyone in my family was wondering how we were going to take care of both her and my children, and God game me the strength to do so. I was getting on with my life, and getting stronger in the Word. I never did get to any kind of AA meeting, it was a meeting with God, and it was He who saved my life by taking all the drugs and drinking away from me.

One day my sister was two days from leaving, heading back for Maryland. She came up to my room and she was traumatized and told me her husband was trying to hurt her. My mother did not know what was going on, she was already sleeping. I woke up early in the morning at 4 am and

prayed with her. I saw that she was having some of the same problems I had with Peter, and I felt so bad for her. Our family had to break that bad cycle and find love and peace in God's Word. She felt comfortable in that God's presence was near. After that night the Lord used me to take my sister to Nicole and the other ladies who were praying for me.

My sister also wanted God in her life and it was fitting that the same woman who helped save me was helping to change my sister. My sister's husband even asked me about prayer, and I showed him how to get over to the Nicole's house for prayer, and he gave his heart to the Lord.

My sister and her husband were much better off but they couldn't reconcile their marriage. They still went their separate ways. She was serving the Army in Maryland and he was in Florida. But their kids stayed home with me at my mother's house. I loved taking care of the children. It was just more motivation to stay away from all the people in that dark world of addiction that I had left behind.

My son was going to school along with my sister's kids. My daughter was still only two at that time. There was very little income for the family, only a welfare check and the job my mother worked at every day. On Friday, Saturday and Sunday I went to prayer meetings.

I kept my life open to God and kept watching Christian television shows. I was over at Nicole's house visiting

almost every day. I would catch a taxi to get there, and it was about 10-15 minutes away. I kept taking my kids and my sister's kids for prayer and teaching the Bible daily.

My mother started saying I was crazy because I felt God present there with us. She did not understand, so I was faithful and kept going for prayer, and asking God to help my mother. This was the only peace I had in my whole life. I kept going to Nicole's house for nearly eight months because I did not have a church home yet.

Finally I got more of my family to come for prayer. I was bringing my niece, and my other sister's daughter came too. They saw the good changes in me and wanted the same for their own lives. We all started going every day and my mother was in a state of disbelief. I only wanted to get closer to the Lord, to have a relationship with Him, a prayer life. I only wished my mother could understand the love, and that we could all be closer in God's name.

Yet just when I things were getting better, Nicole had suddenly changed. She had gotten married to a man she had just met a few days earlier. She called us together and said that there would be changes in the prayer meetings at her house. That from now on her husband would be our new pastor. It didn't work out. Nicole was not the same woman after that.

It was obvious to all of us that Nicole was letting her new husband manipulate her, and we didn't know what to do.

Then we found that she was not even legally married to this man, that her "husband" was the result of a "spiritual" wedding. It was just too much of a curve ball for us to overcome. Our prayer group was finished.

We got hurt over those troubled times that occurred, we were losing our friend. Even more, it felt like we would be losing our direction and connection to God. But God is faithful and I did not want to give up that easy.

I was sad, but resolved that I should never give up on going to church again. Putting your faith in a person is not the way things should be. People make mistakes and you've got to expect that. A person cannot put you in heaven or hell. Our salvation is unto God where He will decide for our lives.

So I kept asking God for a church home to go to for prayer. After a reading of God's words not to look unto man, I prayed for Nicole. All of the ladies stopped going over to her place but we kept her in our prayers. God used her in our lives for just a season, and despite her falling short, it was Nicole who helped us to accept the Lord Jesus in our hearts. And God had a plan.

I couldn't just give up and go back to drugs or the world I knew. Still my sister was concerned about my life, not wanting the same bad things to happen to me again just when I was turning the corner. She talked to one of her

co-workers who was a Christian. She told my sister to take me to a place called Christian Fellowship Church.

My sister was persistent and took me there in April, 1991. When I walked inside I felt so good, and that I experienced God present there. I felt the Lord saying to me in my heart to join the church the same day. I was there with my sister's kids. My older sisters daughter who was 19 at the time was there also. The people in the congregation was so friendly and welcoming. Sadly my sister did not come to services too much after. Neither did my nieces. So I kept going there, just me and the kids, and we were feeling strong in spirit. It was one year after my recovery from the heart attack.

CHAPTER 11:

MAKING THINGS RIGHT

The months went by and my mother still asked why I kept running off to church. I told her I have to go because God is good. I said that I had my whole life to atone for. I ask her to come with me but she did not ever want to. I was going to Tuesday night Bible study, Thursday night prayer and Sunday service. I was feeling more and more confident and positive as days went by.

I was comforted to have found my church home and was growing closer and closer to the Lord. But I had a lot of guilt weighing in on my conscience. I started thinking about Peter still being in jail, and I felt horrible about the lies I told to police, lies based on my own fears of Peter when I was recovering in the hospital. I realized that I couldn't move on with my life until I owned up to the truth.

I went back to court in June 1991 to tell the judge that I made a mistake in my life, and I had a letter that was typed up from one of the secretary's at my church. The letter stated that Peter did not have a gun and that he did not force me to take drugs that night. And I stood there alone before a grand jury to tell the truth about what took place on that night back in August 1990.

While reading the letter to the court I was really very nervous. My hands were trembling, and it was like being back in school when I just wanted to be invisible to the world. I would stumble over some of the words, like I remember having trouble with the word "solicit" and the judge was furious, saying that I could not even read. People in court were looking at me like I was dumb. The Judge told me that I was going off to jail for perjury. The guards came to me in court with handcuffs, put them on me, and took me off to the jail.

They locked me up in the jail and I cried and said to myself dear God, I am only trying to tell the truth. After I accept the Lord in my heart I wanted things to be right. They put me in the phone room and I needed to call my mother, but she would not accept my collect calls.

When I was there I felt that God had called on me. I was able to pray with the ladies and they accepted the Lord in their hearts. After I would pray with these ladies they put us back in our cells. When I got into my cell and lay

on the bed I look at the wall and there was writing on
it, it said "anyone who enters this cell pray in the name
of Jesus Christ and I prayed and on Sunday they had a
Bible study the very next day at the chapel that was there
inside the jail.

They took all of us lady to the chapel when we got there a
minister lady preached to us and before the study was over
with, she asked if anyone wanted to testify. I said yes I do,
and I stood up in front of all the ladies and told them that
God had me in here for a reason. I told them God helped
me get the drugs out of my life and he was watching over
all of us. I was not afraid to speak in front of everyone else,
I just wanted to testify in the name of Jesus.

After I spoke the minister who was there gave me her
phone number for me to call her collect. She told me she
had a daughter that was still in a battle with drugs. We
talked some more and it helped me so much to talk with
her. When she left they took me from the chapel and
back to the cell. I kept praying for all of the Lady's who
was there.

The next morning was a Monday. An attorney came to
my cell and told me I never should have been in jail. I did
not have any kind of criminal record and that I can get
out of there on a personal signature. I was again standing
before the same judge. She told me that she was going to
have another hearing for me to be sentenced coming up

in July. So they released me. Next thing I know I was on the bus and went back to my mother's house.

When I walked in the door my mother confronted me right away. She said I was stupid, crazy and that I made a fool of myself and of my family. They were ashamed of me. There was even a story in the Metro section of the Cleveland Plain Dealer. The article made it sound like I was unintelligent and could barely read. It made it sound like I was the one who got Peter into drugs and was the cause of all of his problems.

My brother and sister told me I must be insane. They wanted to know why I would risk my freedom to go back and tell the truth. They said I betrayed the family, and that I should have left things like they were. I was so upset I left with my kids and moved in with a friend.

I tried to regroup and adjust to the situation of being separated from my family. I thought about all of it and realized didn't have anything to be mad about. Peter couldn't hurt me any more, and I had been set free from drugs. I wondered if he and I could start over again and raise our kids together. I could take him to church and read our Bible. If Peter could only understand God's love, he too could change.

Some time passed, and even though I was living apart from them, my family still felt a lot of animosity toward

me. One day I left the house to pick up my son who got out of school at 3:15 every day. But just before I got there I saw my brother's wife grabbing my son and putting him in her car. When she saw me she cursed me out, and wanted to know how I could leave him to walk alone. I explained that he always walked with the neighbor, and that we always meet up half way home. She called me a liar, but I would not let her take my son away. She drove off and we went back to the house.

I thought things would be okay, but then my mother came by, and she accused me of leaving my son alone. I could not even get one word in to explain the truth; she started beating me up and then threw me down. I tried to run out of the house and she caught me outside, then she slammed me into a car headfirst. I still wouldn't fight back. She punched me in the eye and I was so ashamed that the whole street was looking and my children were watching too. Nobody would help me. I ran back inside to get away from her.

She followed me back inside and I remember my mother and my brothers wife were beating me. I was hurt, and scared, but not once did I try to hit my mother back. No matter what I had to honor her and respect her and love her regardless of how afraid I was. When she grabbed a knife the only thing that stopped her from cutting me was that I asked Lord Jesus to call angels in His name. There was a slash and, amazingly, the knife had only cut

my skirt. After realizing what she had done, my mother just stopped. She got into her car and drove off, leaving me there crying.

I was left thinking how sad to be the age of twenty-five years old and having my children see this happen to me. I had to move out of my friend's house. The next day I went down to city hall to try and find housing for me and my children.

They sent me over to see a lady who was an apartment manager who could find me a new place to stay. When I got there she saw my eye was swollen, and she asked if I pressed charges. I said no. And she asked if I could afford the two hundred and fifty dollars a month and by faith I said yes, even though my only income was less than four hundred dollars a month, leaving a welfare check and food stamps. I needed another two hundred and fifty dollars for a security deposit, so the welfare department gave me a voucher for the money o cover the deposit. The property manager gave me the keys to the apartment, and soon I was living there with my children. It was a two bedroom with very beautiful hardwood floors.

Chapter 12:

Tammy, Things are Looking Up

My kids and I moved in with the clothes on our backs, and some extra clothes in bags. There were no beds, nor blankets, no furniture or refrigerator or food. I called the minister I met in jail and she paid for a taxi to pick us up. At her home she fed me and my kids. She was saying that I was like a daughter to her. It made me feel happy to hear those words. Her real daughter was struggling against a terrible addiction just as I had. She said she still believed God could take the drugs away from her daughter, and we prayed. Before she sent us back in another taxi, she gave me food for my kids to keep in a small ice cooler, where I could keep some milk.

In a couple of days I went to my church and told my pastor that I could use some beds for my family. The kind minister found me beds and some money to get by. Some days later I met a young man who gave me a

living room set and dresser and stove and refrigerator, lamps, and more food to keep. After that I never saw him again. He was so generous I could not believe it. I kept going to the church, being faithful, and Praying to God for a friend that would understand and share my company.

I can't imagine what people must have thought of the odd sight me at the church, but I will describe. At that time my hair was short, so I would put on fake hair to go out. My clothes were always way too big for me. I had panty hose that was so big they came all the way up to my chest. My shoes so crooked I said only God he would make my crooked path straight.

I wanted to tithe so much when I went to church I would scrape up change wherever I could, or put a food stamp in the offering plate. My pastor always wanted to know who put food stamps in the collection plate. I was so ashamed to tell anyone that it was me. I wanted to give so much I gave the only thing I had.

Some days later on a Sunday we had a prayer line, I wanted to be sure that God would continue to deliver me from drugs. I was clean for over a year, but I wanted to be sure I was over it. I got the prayer line for more prayer and I just kept getting back in line. When my pastor saw that I kept coming back, she prophesized to me that God would have me to write a book about my life.

I was still praying to God for a friend when the service was almost over. Right then I noticed there was this lady was standing next to me. I introduced my self and learned her name was Tammy. She asked, "What kind of woman are you?" I expected her to comment on my appearance, and I braced myself for the worst. But she said she had never seen faith like I have. And she said it was wonderful how I kept getting right back into that prayer line over and over again.

Tammy asked did if I had a way home. I told her no, that I would catch the bus. After all, my apartment was only fifteen minutes away. While I was only at this church about 4 months, she was a member for over eight years. She told me she would take me home in her car. On the way home we agreed that it's a really good church, a place that welcomes all people. Next thing she offered me something to eat, so she took me over to the Bob Evans restaurant.

We ate talked some more. I told her a little bit about me and she was overjoyed to hear how my life was turning around for the better. She asked if I wanted to come to the library to type up some of my experiences on the computer.

I was wondering what in the world she meant, but she replied that "you can write a book, and help show people God can change a person. A book can be like a record, and the pastor can use it to speak about my experience

getting over drugs and hope that the Lord would grant anyone a new beginning."

We did go down to the library, and after watching her typing on the computer for a while, Tammy asked me again, to write a book. I could only stare back at her. It was funny that she could see just how nervous that made me, and we both laughed. She gave me her phone number. Took me back to my apartment. Tammy told me any time I need prayer or anything at all, that she will pick me up and take me to church service.

While things were slow to mend between me and my family, there was something else that I was forced to reconcile in a hurry. It was time for me to appear in court. I was worried, thinking about that date, but I tried to have faith. The day before I was to go to court, I prayed and prayed for help. Then before I knew it I was there, in that room, standing alone before the judge. That judge told me that if I was any body else she would have given me five years sentence for perjury.

But I testified and asked the court for forgiveness, and she saw that I was being sincere. She suspended the sentence and it was all over. I thanked God because the judge took my words to heart, and she did not even really know me. But I knew who did know me, the Lord Jesus Christ. After it was over, I went home and prayed and thanked God some more.

I was seeing Tammy all the time. She kept picking me up to take me to church and after we would go to dinner and fellowship and laugh and pray over situations that occur. She was really helping me feel better.

One day she found that you could apply for aid if you had a child with a disability. My son had some problems with his vision that affected his ability to learn and so I applied in September 1991. They began testing and gave notice that he will be able get the extra help he needed to stay in school.

Life was getting so much better, but I was not yet free from my bad decisions in the past. I knew that Peter would be out of jail eventually, and with the passing of each minute that that day was drawing closer. But I was not really sure of what exactly was going to happen. If he chose to, Peter would be a free man to do whatever harm he was able. I didn't truly grasp how this would change everything.

I had since forgiven him when I gave my heart to Jesus, and prayed constantly that he could be redeemed. But it turns out that Peter was determined to make my life a pure hell once again. He got out and wasted no time breaking into my apartment. He stole money I was saving along with a color TV and a stereo. But worst of all he took away the children's clothes.

It was obvious that he was desperate, and out of control because of his addictions. My suspicion that peter was

back on drugs was soon confirmed. He confronted me and said that he wanted to get me back. He offered drugs, figuring he could lure me back that way. I told him that God brought me this far, and there was no chance of going back to the way things were before. I wanted my things back, so Peter took me over to a drug house where he had brought all my things. I did not have the money to get anything back. They wanted one hundred and fifty dollars, and Peter had taken my last dime.

I went to my church and they were kind enough to give me the money to get my stuff back. I gathered my strength and went back to the drug house to confront Peter. He told me he was going to get everything back for me and that I should stay put. He went into that house and I waited and waited for him to come out. He simply walked off with the money the Church gave me. Knowing I had foolishly lost the money that was entrusted to me, I was once again in a pit of despair.

I knew I needed to get away from Peter Johnson and never look back. I needed a way out because he would be determined to bring me back down again. I said to myself that I came this far, too far to go back to being like a slave in Egypt. I started prayer for God's mercy to get me out of this situation. I prayed that my family could help me. I wish I was stronger but I, but Peter was soon spending all his time at my apartment. He grew more possessive, and just like before I was once a prisoner in my own house.

CHAPTER 13

MEETING TIM

Peter did not want me going to church. But I knew my life depended on God, I could not let this man stop me from attending services. He was becoming violent and I was in a constant state of worry for the kids. We needed to run away from him. In December of 1991 I called my property manager and told her I needed another place. She said to call her back in a few days and she would check to see if anything else opened up.

The next day Peter was driving my son and me in the car. Our daughter had stayed over with Peter's sister and we were going to pick her up. He was quiet, more so that usual. We drove a while without him saying a word. Then when he finally spoke, he told me matter of factly that he felt like killing all of us as he was driving. I knew his threat to be serious, and I could tell that he was losing his mind. The look in his eyes just wasn't right. I jumped out

of the car while we slowed down at a light and I fell to my knees on the street.

Looking up and seeing a nearby grocery store, I quickly got to my feet to run. I went in screaming for help, begging for someone to call a policeman. But to my astonishment, everyone there was staring at me like I was some kind of ghost. I told them my ex-husband was dangerous, and if they didn't believe me at first they would soon learn otherwise. That's when Peter came into the store holding tightly onto my son. Anyone could tell right away that he was unstable. I tried to pull my boy away from him but he would not loosen his grip and he tried grabbing at me. He shouted to people in the store not to pay any attention to us, and that I disobeyed him like this all the time.

I started begging for my life, and for my son. Finally the store manager gave me the phone to call the police. This was all it took to frighten Peter, and he took my son and he hurried from the store. I was terrified that he had my boy. And before leaving he threatened that I wouldn't see our son or daughter ever again.

About fifteen minutes later the police arrived and they drove me to Peter's sisters house. I worried for my son and hoped to God we could reach my daughter before Peter got the chance. Thank the Lord, Peter had left the boy with his sister. Both of the kids were safe. Peter was arrested and the police took me to the women's shelter over night.

Peter wasn't in jail for long, and I was worried, wondering how I could get us moved out of the apartment without him knowing. Peter confronted me about his arrest and I was afraid because he had taken the apartment keys away from me. He was thinking that I wouldn't dare leave if I was unable to lock the door. But I left anyhow and prayed to God for the little things I had, it would still be there and I got back.

My old apartment manager was worried and found a new place for me and the kids to get away from Peter. I went over to a grocery store and asked an employee there named Tim if he could help me get some boxes together. He was a nice man, he knew Peter, and that alone made him want to help me to get away. He told me not to take any boxes, because that would make peter suspicious. He had a better plan.

I went back to the apartment and Peter was there, strung out enough that I was not a high priority at the moment. Peter had brought over some strange people, a man and a woman who also looked high. Peter asked me for money, but I told him I didn't have any. I really only had a hundred and twenty five dollars left and some food stamps. Thankfully the property manager had it hidden over at her house. I gave Peter ten dollars so he and the others could leave the apartment for who knows where.

Unfortunately, he ended up lingering around and didn't actually leave until the next day. But as soon as he did, I

followed Tim's advice and immediately went over to the neighbors. I called some friends who came with a U-Haul truck. For the one hour and 20 minutes it took them to get my stuff out of there, I was trembling and afraid, shaking nearly to death. My friends told me not to worry about Peter because they would not let anything happen to me. Soon they were finishing up, and my children and I got out of there.

A couple days later I called Tim at the grocery store and thanked him for his help. He came over to see me and I introduced him to my children. He was genuinely concerned about our safety but had a reassuring tone about him and we talked for a while. He also said that he had just gotten out of a relationship and he had a daughter who was three years old. He had been deeply hurt going through a situation with his daughters' mother. Before leaving, Tim asked me if there was anything that I needed. I told him no, and he said if I ever needed anything at all, to call him at work.

Tim started coming over often to see me and the kids and buying food for all of us. If we had anything extra, I would promptly bring that over to my mother. I thought that this would bring us closer together, as I desperately still needed my mother in my life. I tried everything for her to accept me as her child. I put our bad experiences behind, and I forgave her for everything that happened. God mended the relationship a little, but I still believed that God would show her salvation and healing.

I was fortunate to avoid Peter for a while. Then I went by Tim's store one morning to see him and I didn't know at the time that Peter was following me. When I saw Tim, Peter came up from behind me to confront him. He was yelling, "Do you both have something going on?" I was never able to stand up to Peter. I just froze. He began to scream at Tim and I, right in the middle of the grocery store. Tim calmly told me to go to the back of the store, and that he will handle Peter.

I wasted no time, and ran to the back where a co-worker, who was friends with Tim, showed me out of the exit door and into one of the store vans. Tim's friend drove me to my mother's house, which was not far from the store. When we stopped in front of her house, my heart fell as I saw Peter pull up behind us. I ran to the porch and knocked on the door, begging my mother to open up. And just like that she appeared. When Peter saw my mother open the door he got back to his car and drove off.

When Tim got off of work he came by to pick up me and the kids. He reminded me to be watching out for trouble all the time. And he was right. I could not go anywhere by myself because Peter was trying to get back at me. My mother had to pick me up whenever I needed to go somewhere. Tim didn't own a car, but he could use the store van to take me places or his co-workers would take me around town. We were getting along great, and I was enjoying any time we spent together. For the next

six months Peter stayed away, and this allowed my life to go back to normal.

Getting to spend time with Tim brought a lot of joy to my life. With him around, I always felt like he was my bodyguard. While he wasn't tall, or short for the matter, he had a solid build that some people would call "husky." His parents were from Mississippi, and if you listen carefully, from time to time you can hear traces of Southern drawl come out in his speech. He was old school, and I appreciated that fact. There was something dependable about the way he seemed, with his short, box cut hair and how he always dressed nice with khaki pants and white shirts tucked in.

Tim appreciated the good things about me. He saw the parts of me that I wanted most to fulfill, that just wanted to be an old fashioned woman who loves to keep up a home, carry herself well and love her children. It didn't hurt of course that we could just talk for hours and hours. It was wonderful because we could talk about anything, though what we really connected with was my original love, TV. Tim was a big fan of movies and classic shows like Lost in Space, sci-fi and anything involving History.

Tim moved in with me in March 1992. I was glad to be honest, but part of me still felt really bad because I just began my Christian walk with God and we were not yet married. We soon agreed that to do things the right way,

it would require either him moving out or he would have to marry me.

We were both still hurting from our past relationships, but realized that we needed each other to get through it all. We ended up trusting in one another, and we got married. I really wanted a church wedding, but settled for a ceremony at the courthouse. We did not have a reception but I didn't mind, I was happy and I was safe. It was August 12, 1992 and my new husband went to back to work like normal, just like he did every day.

I went over to see my mother to tell her the news about Tim. I wanted to tell her about how happy I was to have my kids and good friend Cindy there to witness the ceremony. I wasn't ready for my mother's reaction. She told me I should have waited before getting married, that in my case it was okay to keep "shacking up" with Tim. I told her that was wrong before God's eyes, and I wanted to start again by doing the right thing.

The very next Sunday I was at Church. I was there alone because Tim had to work. Peter came in and sat right next to me, trying to scare me in the middle of service. I got up and went to the church office to tell my Pastor's secretary about Peter. She prayed with me and asked me if I wanted to go home. I nodded, and the church secretary called my husband from work and he came to get me. Tim pulled into the lot and one of the church elders walked me to

the car and I was relieved to see my husband. When I was getting into the car, Peter walked outside toward us. The elder told us to hurry and we drove off, leaving my Church and Peter behind.

Tim dropped me off at my mothers until he could come and pick us up after his shift. I was wondering how I could get through life with the chance of my ex-husband showing up to torment us at any opportunity. It made me afraid for Tim, as well as the children. I was afraid that we would never have peace in our lives. Then a few days later Peter was arrested for robbery. He was eventually convicted, sent back to jail, and that was the last I had heard Peter Johnson.

Chapter 14:

Second Chance on Life

Knowing Peter was jail was a great relief to us all. I was able to breathe easier and try to center myself. I kept on going to church and mending relationships with mother and my kids. Soon after everything got calmer in my life, it was time for me to go back to school and make something of myself. I wanted to get back to square one, and start over.

I was getting a second chance on life, but not everything would be easy. Our marriage, like any other, was going to take a lot of work and cooperation. Tim was going through some hard times personally. I was worried that the foundation of our relationship would be shaken.

He stopped going to church with me, and he started back with drugs, drinking and staying out all night. I was so upset, wondering if this could be real. I did not want to

accept that someone as strong as Tim could have a drug problem. I kept saying to myself it's just going to pass over. I was so scared at losing him, but all the while I kept praying, believing God for our marriage.

Tim said he was taking our car to get fixed, but we never did get it back from the shop. We started riding the public transportation again and we was staying in a two family house. It was not a good situation, mostly on account of the lady and her daughter who lived down stairs from us. They were strange. We would hear them walking around, muttering and shouting all night long. There was talk in the neighborhood that they were involved in some kind of bizarre religion. Once they left two dead fish in a bowl by my car, and naturally, my family was alarmed at this. Thinking it was some kind of strange practice, we had our house blessed in Jesus name.

On one morning I went to church, Tim stayed home as usual. After the service my friend Tammy and I went to our favorite restaurant, at a place called Baker Square. Usually everyone from church went there. We ate and after we left the restaurant and Tammy was taking me home. When we pulled in I was alarmed; I had noticed our house had a large burned spot around the window.

I was afraid to get out of the car, I knew Tim was in the house and feared for the worst. Tammy told me to calm down. She went up to the door to see if he was okay while

I stayed in the car. When Tim came to the door I was overjoyed to see him alive.

He came by and told me it was okay to get out of the car. I was still shaken. He said the people downstairs had a fire that got out of hand, and that there was proof they were into the occult. We knew this because as the fire department came, they started throwing all sorts of books outside the window. There books dealing with the devil and sorts. The neighbors weren't home, they had some candles burning and left them unattended and they caught on the curtains.

All the people on the street were talking about the weird neighbors and said we were lucky. I thanked God that nobody got hurt, but I told them it had nothing to do with luck. I said we were safe because of a blessing from God.

We had to move away from that place, and I started feeling afraid of what was going to happen. The downstairs apartment wasn't so bad off that the neighbors had to move out, so we were fearful of living so close by. I prayed to God to not give me a spirit of fear. Tammy said to me the Holy Spirit holds the right path, and never to run because God will give me another home and be still to know God is in control of the situation.

The neighbors were once again screaming at each other downstairs. The daughter said to the mother "you know

evil and good don't mix, and I am a believer of Jesus Christ. I am not to judge, God has to let them know God's power is greater then any devil." I was in prayer for those women downstairs. I knew that no evil can stand against the might God. And afterward they moved out and nobody heard from them again. A month later I was looking for housing. With the kids getting older, I was hoping a place with three bedrooms would give them the room they needed.

Tim's troubles were getting worse. He would come home late at night just a completely different person. One night be came after me and I started prayer and called my angels in Jesus name. I was praying and thank God he came back to his senses. God stepped in to protect me and Tim went to his knees, crying. The next day I wanted to separate from our marriage have some time for Tim to get under control.

Tim would try to get his life back in order. He needed another job, as his current job wasn't paying much. For too long any extra income he did earn was going toward drugs and alcohol. His job did not have any health insurance and he finally went to another company that paid more money, but still no health insurance.

Tim had learned a skilled trade, his line of work was meat cutting. When he was working for the other grocery store they only had him as a stock person. But he knew about

cutting meat since he was 15 years old, and at the new job he was able to go back to what he knew best.

He was still in a battle with drugs and kept praying and believing God for our marriage. It was hard, but I promise it was nothing near as bad as before I accepted to Lord in my life. Where as before I was so worried and afraid that I had to make sure my hair would not fall out in church. Now I was thankful to God that my hair had grown to my shoulder. I finally looked and felt like a stronger person. I thank God for his mercy and grace each and every day.

I was sure that my husband was back on the right track. But sadly, he started messing up with his new job. I was worried he was going back to drugs. One day I was waiting on him to come home from work and he was several hours late. When he did come home later that night, he told me that he had made some big mistakes with our savings, and that he was sorry.

I was feeling sick and light headed, I fainted and my husband called the ambulance to take me to the hospital. The doctor told me I was suffering from dehydration, and they gave me an I.V. to make it better. They discharged me to go home at five thirty in the morning. I called my husband to let him know. Since he did no longer owned a car, I told him I would walk home. I was ashamed to call anyone to tell them to pick me up from the hospital.

As I was walking I walked passed everyone dealing dope. Even that early, you would be surprised how many people are out there selling. They would ask me if I was straight, and I said "yes, in the Lord" and kept walking home.

I made it home safe and sound, when I got in my husband had breakfast for me and told me he was sorry, and my kids were there for me waiting with open arms. A few days later I just wanted to get away from it all, I was depressed but kept going to church. I prayed and prayed that things would get better.

Chapter 15:

Train Up a Child, The Way He Should Go

> Train up a child in the way he should go. When he is old he will not depart from it Proverbs 22-6.

While at church I remembered that when I was a little girl, it was my grandmother who had first tried to teach me about God. She told me a little about the Bible and I can still remember the beautiful songs she would sing. I would try to hum the song like she would. I thank God for my Grandmother. Things may not have gone so well with our family and she has since passed away. But she did try to tell me about God, and I loved her.

As I grew older I thought about her more and more. I started to realize the true love that had surrounded me all along. I just was on the wrong path. I was too young, too hurt, confused and unable to see the truth.

Time went on, and I was faithful and did not depart from God. I love the Lord with my whole heart and soul. I kept going to church any many prayers were answered. I prayed for friendship, and me and my good friend Tammy became so close. We stuck together throughout life's trials. To put it simple, she is just a very loving friend. Also my old property manager, Mrs. Karen Smith and her co-workers Nancy Gregg wandered the same path and stuck through all life's situations together. I have to mention their honesty and love. I thank God for true friends.

I thank God for them each and every day. I told my husband we needed to work out the trouble in our marriage. I was confident that through faith, God could help us to fix anything that was wrong. I didn't want to lose what we had together. Tim said he would go back to church with me and I prayed that he could find a job closer to our home, one that had health insurance. And we needed more time to just be together. He had been working far across town, a forty-five minute bus ride away.

It turns out we were fortunate, that God provided us another chance. It happened the day I made an eye appointment for my son. I told my husband to come with me to the Eyeglass Factory to pick up some glasses. Tim caught the bus with me, and when we got there he saw there was a grocery store just down the street from that place. He went right in and filled out an application.

I prayed over the matter and a couple of days later the store called back. They wanted my husband to be a meat cutter, his trade, offering good pay and health Insurance too. I started thanking God and praising God but there was something wrong with Tim. My husband was not as confident. He did not want to take the job at first because he felt afraid of failure. I called my good friend Tammy, and we prayed about the situation and finally two days later my husband told me he was going to try the new job. His confidence was regained and was off to work.

A year went by and we were able to save some money. At that time we were still in the income-based townhouse. Tim's salary was good and though I still wasn't working, I was finally off of welfare and the property manager raised our monthly rent. I felt our income was enough to buy a home, but Tim was skeptical. He felt if something happened to us they would reduce our rent to a more reasonable rate. But I did not want to rely on that; I knew that God would supply our need through his riches and Glory. It was always dream to own our own home. I kept looking for a house and praying. I thanked God for what we had; it just felt like no matter how much we liked the townhouse, it just wasn't ours.

I wanted to leave a good inheritance for our children, and I felt like owning a house would be a strong, positive step toward that goal. I called my old property manager to ask if anything was available and she said they did have plenty

of new houses they were putting up in the inner city. She told me to come to her office and put in an application. Tim gave this his blessing, and soon after there was a four bedroom with a finished basement available for a good price.

She told us it was a rental, but in fifteen years you have option to buy the home and we were definitely interested. We were waiting for our income tax to come back in a couple of weeks for the down payment. She trusted us to bring the money back when we were able, so she gave us the key to the house without any money on it.

I started praising God and thanking Him. We moved in during March, 1997, and when we got our income tax we brought her the money. I had the house blessed and thanked God again and again. But for us, there was still a hill to climb.

Tim was back in the struggle against drug addiction, and he was frequently out all night and spending all of our money. I needed a job, so since I loved working with kids, I went for training. When I took all the classes and finished them I got my license working with the County. I had to charge the parents based on what they can pay me, and at times I would not get paid because the parents simply didn't have any money. I couldn't refuse their children. I loved them, and I wanted to help out any way I could.

I loved my work, but I wasn't making enough for the family. Sometimes I would get a little down. I needed to try to keep things together and get our bills paid.

Tim was getting frustrated over our money issues, as he was embarrassed for wasting so much of it. He knew that his actions were hurting our family and this weighed heavy on his conscience. I kept praying for him. It was apparent that other people were desperate for money too. One night while we were sleeping someone tried to break our security door off the house. I thank God Tim and I weren't hurt. When we got downstairs to see what was going on, we found our door almost broken in. It was hanging on the hinge, held up by one screw.

CHAPTER 16:

MY MOTHER'S HOUSE

The reality was that our bills were piling up, and we were just getting too far behind to stay above water. I went to the property manager to tell her that I was sorry about the late rent. We were in further trouble as, because of a change in insurance, I was no longer able to hold childcare.

I prayed for some guidance as for what to do next, and the Lord led me to call my mother. I asked her if I could stay with her with the kids and she said yes. It was a painful, though Tim and I thought it best to be separated for a while. It was a mutual decision. Tim helped me move to my mother's house and he found a one-bedroom apartment closer to his job.

It was August of 1998, and once again I was back living with my mother and my children. Everyone was saying it

was crazy to leave a brand new house. I was sad and that's just the way things happen sometimes. One day God will give me another home just as beautiful as that one. I can't worry about it anymore.

Things didn't get any better back with my mother. It was a difficult situation that was getting worse. My son started in with a rough crowd, a way at protecting himself from an even rougher one. There were gangs coming after him in school and that was a constant worry. While I tried to keep my son on the right path I watched my mother grow more and more distant from all of us. She started saying she wished we got out of her life. That she would rather be off by herself.

I prayed that I could be closer with my mother, yet she just didn't want us. We needed somewhere to go. I called my old property manager for some help, but there was nothing available. So I went to church with my good friend Tammy. At the service we had a guest speaker, a man named Kelly and his wife Ramona who were Pastors that made it their life's work to help homeless. They just started taking them into their home until God provided for them to open a shelter.

After the service was over, Tammy was interested in helping any way she could. So after church we all went to lunch with Pastor Kelly and his lovable wife Ramona. Lunch was great, and they invited us to their home where

they showed us their camper. As we were sitting in the camper, Pastor Kelly felt like me and my children needed to move in with him and him wife. I was saying to myself this is crazy, and after we left Tammy took me back to my mothers House.

My son was still going through a stage of rebellion, he was so hard to deal with and I didn't know which way to turn. My property manager said it would be about a week before anything was ready. I was feeling really upset, and my mother wouldn't stop screaming at me. I felt like just digging a hole and hiding somewhere. Finally my daughter said to call the Pastor and his wife. I told her that was a crazy idea. I even considered going to Tim, but his apartment was so small and I knew that was no real solution.

I spoke to a friend on the phone that reminded me that sometimes we have to do things we don't want to. As hard as things were in my life I never really thought of myself as ever being homeless. Yet here I was with my back against a wall, needing help, my children and I were homeless.

She felt God is leading me to stay for a little while with the Pastor and his wife, and she told me God's knowledge and understanding is higher than we can understand. She said obedience is better than sacrifice and after we spoke I prayed for God's direction. I called Pastor Kelly and Ramona.

They told me that they were supposed to take a trip. That they were supposed to head out a week ago, but they got delayed. They ended up postponing the trip and they came to pick me and the kids up from my mothers. When we got to their house, they continued packing for their trip, feeling that they could now leave me the keys to the house and car. I told them I couldn't drive. So they left food for us.

Pastor Kelly and Ramona left me at their house for two weeks. And things started getting better for me. I felt a peace of mind and called my old property manager back and she said she could have a new place in two weeks. I thought we would be in the way when Pastor Kelly and Ramona got back, so I asked Tim if we could stay with him until the new house was ready. He said that was okay, and he made room in his small apartment. My son slept on the couch and my daughter slept on a mattress on the floor in the living room and we were comfortable there together.

When the property manager gave me the key to the new place, she prorated the rent and thankfully, she saved me some money. We all moved in, Tim included, and I felt really good. It was October 1998. When you can be obedient to God He can work out your situation, like the kindness showed by Pastor Kelly and Ramona, people whom I just met, when I needed a place to stay. God moved their actions.

And I remember when I gave them back their house keys, I thanked them and tried to give them some money but they would not accept anything from me. I moved on with my life keeping their kindness in mind. God led me back to hosting childcare. The property manager did not mind keeping kids in the house, and I was able to do this in the new home.

CHAPTER 17:

REFLECTION AND PURPOSE

The good times continued, and things got much better. All the while I kept at church. After nine years I had found a comfortable home there. Although now it was farther from the new house, and when my friend Tammy started having some car trouble, it was hard just getting there. Just then my husband told me about a Pastor and his wife that he met when he was working at the store. They invited us to their church close by, and we went as a family.

The church was right within walking distance to the house. We would go every Sunday, Tim had to work some Sunday's, but he would go when he could. Yet we soon found our new church close by was moving. Pastor Johnson and his wife told us they were relocating to another state. We were there for just a season. All the while I kept missing our original church, the Christian Fellowship.

I had to keep the obedience for what God wanted for me. But I knew I didn't want to hop around going from church to church. I moved a lot in the past; moving from different apartments, always looking for escape, each time hoping for a new beginning. I did not want to move the same way from church to church.

With Tim, I felt like there was still some real hurting in our relationship. I could not let my emotions falling back into the depths of depression, not when I needed to be strong enough to help my husband. I called my friends over and they all prayed with me. And after the prayer God brought back to my right frame of mind again. There was no way I could backslide into feeling bad after the strong prayer. I got back into my Bible and God changed my heart around like I was remade.

I always wanted to get rooted and grounded in one church, I did not mind visiting other churches, but I just always wanted to be rooted in one church as a home. I started going to classes Believe God that I can open a women's shelter and everybody in my family kept asking me what I'm going to do about a job. I prayed to God that I wouldn't have to get back on welfare. There's nothing wrong with welfare if you can't do any better, but it wasn't for me. I could work.

I asked for God for help, once again saying I am your child, you will supply my needs because I belong to You.

I did not have to beg or steal, I just trust in God and he made a way each and every day there was food in the freezer. And God's word said in Psalm 37, "I have been young, and now am old; yet have I not seen the righteous forsaken,

nor his seed begging bread." There is a Saver, a Healer and a Provider for everyone. He is everything if we can just welcome Him into our lives, He will lead you and guide you that's why I am writing this book, to let the world know God is God and no other.

With a clear mind I began to take some classes. Some were to learn more about business, and other classes about learning to deal with abuse. People around me were asking me what kind of job I wanted, or was I going back to doing childcare. I tell everyone not to worry about me, about money, because money is not my purpose, and not a day goes by when God does not meet my needs.

I do not have to beg, or go back on welfare, or steal or sell drugs to get by. God worked through people to help take care of my needs. I think people forget who God is and they say they have gotten wealth on the own. No. God gives you power to obtain spiritual wealth. And I can say God loves us all and is my source, a mighty fortress, and my healer and redeemer of life. I kept prayer for my family and God answered my prayers, each one.

One day my sister and brother came over to my house, I believe God healed our relationship. In the past there was so much pain there, when they came over, after not seeing them for so long, I simply thanked God for them. Now there was only forgiveness and love. They saw how I was living and that I was now a stronger person. I love my sister and brother. I just wanted a relationship with them that I never had before and I pray many years to have a relationship with my brother, sister, and my mother.

God answered my prayers with me and my mother. We talk each day and we have a relationship growing daily. And also my children are making good grades and learning to respect each other and we are taking it day by day with our relationship, getting closer and closer.

Tim, my loving husband came back home in February 2001. We reconciled our marriage, he has been going to church and mending our marriage, sharing each day on a firm foundation of God's love. We are taking is slowly, day by day in our new chance at life. God healed me, and He has looked after Tim as well. And I'm thankful of everything that God is doing in our lives.

I have a dream that someday I could open a shelter for women and children that have suffered abuse. I believe that writing about my experiences can help bring me closer to that goal. For now, I am excited about what God is doing in my life, and I am thankful for His mercy

and grace. I can look back and say that the things I went through in my life seem crazy. I could just as easily be dead by now. But God saved my life. He had a plan, and a purpose for me.

This is a true story about my life, and I pray people can be encouraged with this. I pray that I can somehow help others to find Him, and to seek out His love. Even if you don't believe in God, I can promise that He is real. God will be your light and hold you closer than your family or closest friend. He is always there when you need someone. Through everything, the Lord's hand is in it all.

In closing, ask the Lord Jesus Christ to come into your life and heart. It only takes a minute with a short prayer to God. He is only one prayer away. Confess Jesus Christ is Lord and ask Him to forgive you of your sin and He will answer. That's all it takes. He will open his arms and accept you as you are. And be encouraged. God is love.

Epilogue

I don't care what kind of religion people say they are, there's only one God. Why people try to make like God is different in each different religion I will never know. I just need God, and to have a relationship with Him and to talk with Him. I am afraid that people miss this whole concept of God and turn it into about differences in religion. Man made religion. God made man and He wants man to turn to Him, not Religion. Turn to Him with your mind and heart, and start up a relationship with Him. Welcome God's spirit. You cannot communicate with God until you accept Him.

It all started back in the Garden with Adam and Eve in Genesis. When man took a fall when both his wife ate from the tree. They lost their relationship with God and the curse got passed down from generation to generation. Man made up religion in the belief that was an organizational way for all of us to reach God.

No. I don't believe it works like that. When you accept the Lord in your life and ask Him to come into your heart and ask for forgiveness, He will forgive your sin and wash them white as snow. And He will accept you as his child. You can communicate with him daily in prayer. You can read the Bible and find a church that will help keep you strong in the Word of God.

Go find yourself a church. I like non denominational. Find a place where people can't get hung up on the religion or politics of the church. You can't be worrying about different things like that because it all boils down to the reason why you're going to church. That reason is to praise God.

If people keep their eyes on man, the motives are wrong because people cannot put anyone into heaven or hell. Only God can do that. He is over our souls. If we keep watching people in church, and they continue sinning, clean your own temple and pray for them and love them anyhow. Because everyone falls short, there really is no perfect church. The only perfect place is in God when He arrives in your heart.

The good news is that Lord is coming back. So please know the truth will make you free. The truth is in the Lord Jesus Christ and people need to stop looking for every kind a doctrine that comes their way. Just believe in your heart and confess Jesus Christ is Lord. He will save you from all of your sins, and He will heal your land.

You don't have to delay coming to the Lord saying, "I got to clean myself up" before I do go. Just come to God the way you are and He will do the cleansing in us. I have been though my share of trials and tribulations and I finally learned to stand firm in God. God said in his Word, that we would all have these trials and tribulations in John Chapter 16 Verse 33. We need to be a good cheer because God loves us all and He wants His people to turn back to him and have fellowship and relationship in Him. That's all He wants. And we as people exist throughout all the denominations.

There is only one God and He loves us. And He wants us to confess to Him not to man, and he will direct our path. I can say that after all the things I went through I finally found it. I can experience all the joy because after all, God is true. We don't have to put our trust in man, or money or houses or any other care of this world.

We can just put trust in God, but too many of us put our trust in everything else. But God will always be the same. God is today and forever. If we put trust and faith into the Lord He will make us whole, and He doesn't look at our color or past mistakes when He sees us. He has love for us. Through His work we are made of all colors of life and are beautiful in His sight.

Let God arise and let the enemies be scattered. God knows the days and the years and He knows His people.

He is a provider and healer. God said in the Book of Isaiah that if people can turn from their wicked ways He will heal them. And I can say that God heals me from any bad situation.

He is a loving God.